ENGLISH CARICATURE

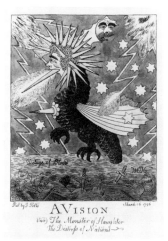

CAT. NO. 121

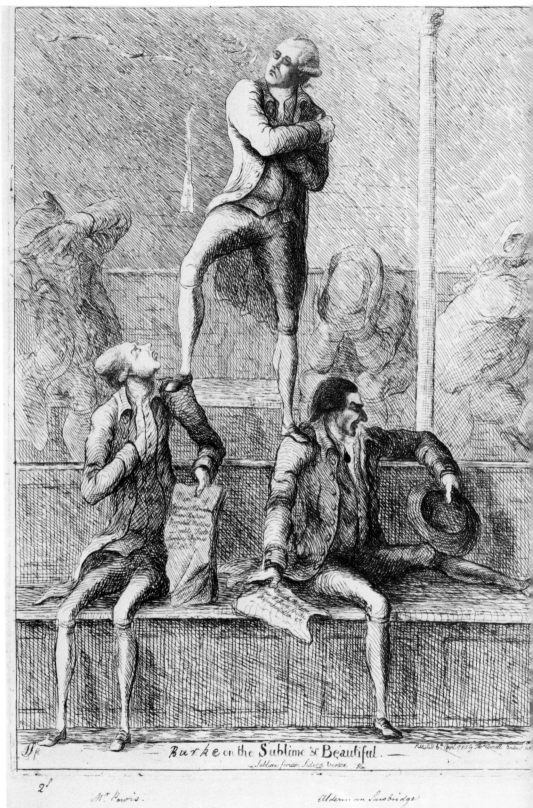

Burke on the Sublime & Beautiful.

— Sublimi feriam Sidera vertice. — &c.

Published 6th April 1785 by Tho Cornell, Bruton St

2 s

M.r Powis. Alderman Sawbridge

ENGLISH
CARICATURE

1620 TO THE PRESENT

———

CARICATURISTS AND SATIRISTS,
THEIR ART, THEIR PURPOSE
AND INFLUENCE

VICTORIA AND ALBERT MUSEUM

Published by the Victoria and Albert Museum, London 1984
© Victoria and Albert Museum
© illustrations: as acknowledged
Produced by the South Leigh Press Ltd, The Studio, Lavender Cottage,
Chilcroft Road, Kingsley Green, Haslemere, Surrey

ISBN 0 905209 95 8

Distributed in all countries other than USA and Canada
by A. Zwemmer Ltd, 26 Litchfield Street, London WC2H 9NS

Catalogue of an exhibition held at:
The Yale Center for British Art
The Library of Congress, Washington D.C.
The National Gallery of Canada, Ottawa
The Victoria and Albert Museum, London

Phototypeset by A.K.M. Associates (U.K.) Ltd, Ajmal House, Hayes Road, Southall, London
Printed in England by St Edmundsbury Press, Bury St Edmunds, Suffolk

CONTENTS

PREFACE

This exhibition, the most comprehensive to be attempted in America, is a survey of English caricatures and satires from the grim anti-Catholic prints of the seventeenth century to the irreverent cartoons of today. Comic, indelicate, sometimes deadly serious, they are a vital part of the country's visual arts and a running commentary on its history. It is not a neglected subject: the greatest artists such as Hogarth, Gillray and Rowlandson have been the subject of scrupulous research, and political and social historians have not been slow to recognize the documentary value of caricatures. However, this is not a caricature history of Great Britain, but rather an attempt to present the greatest practitioners of the art, who are too often regarded as mere vehicles for a graphic idea. That having been said, the exhibition illustrates many aspects of British history, from the monstrous hairstyles of the 1770s to the Falklands War of 1982. The amount of material from which the exhibits have been selected is truly formidable. More than one hundred artists are represented, but the necessity to show the work of the major figures fully has inevitably led to the reluctant exclusion of many interesting examples. It is not an exaggeration to say that each exhibit suggest another exhibition.

By its nature the subject is allowed most licence in democracies, and it is appropriate that this exhibition should be shown in the capital cities of Canada, Great Britain and the United States of America, as well as at Yale. It is the historical birthright of public figures in these countries to be exposed to public ridicule and although they may not always like it, in Winston Churchill's words: '. . . they are quite offended and downcast when the cartoons stop. They wonder what has gone wrong, they wonder what they have done amiss.' Great targets of the caricature, such as Charles James Fox, George IV, and the Duke of Wellington, have also been eager collectors. Yet the art has not been neutered by the approbation of its subjects.

Some of the exhibits are complicated, even learned; others are contentedly free of intellectual content. It must be remembered, before the subject is harnessed, foot-noted, and led off to the stables of art history that its intention is often merely to amuse, to deflate the pretentious or expose a plump backside for a coarse laugh. It is also a blunt instrument for the expression of national prejudices.

Much of the best writing on the subject in recent years has come from America, and it is not surprising to find there rich collections of English caricatures. One purpose of this exhibition is to reveal the strengths of these collections. Yale University boasts the substantial one at the Yale Center for British Art, especially rich in Rowlandson, and the Auchincloss Bequest of Rowlandson and Gillray prints at the Beinecke Rare Book and Manuscript Library. Additionally it now holds the great collection at the Lewis Walpole Library in Farmington, amassed by the late Wilmarth Lewis as a documentary adjunct to his studies on Horace Walpole. A large part of Walpole's own collection of caricatures is now in New York Public Library, which also has a fine collection of Gillray's prints, and an unrivalled one of his

drawings. The Pierpont Morgan Library owns the twelve volumes of the Peel Collection, an exceptionally comprehensive assemblage of prints.

One of the largest and most historically interesting collections, and also the least known, is the one now in the Prints and Photographs Division of the Library of Congress. This houses what was formerly the Royal Collection of English caricatures, which was purchased en bloc in 1920. Although Hogarth and Rowlandson were retained at Windsor, the collection still amounts to nearly 10,000 prints, including many rare and unrecorded examples, and beautifully fresh impressions purchased when first issued. Most seem to have been bought by George IV over a long period, and include many prints on Royal themes – amongst them some that he paid to suppress. His occasional discomfiture is more than outweighed by his evident delight in the subject, which extended to the purchase of satires from earlier periods, and a large number of French revolutionary prints. This historic collection forms the heart of the exhibition.

American collections have not formed the only source for exhibits. Many of the Victorian drawings are from the Victoria and Albert Museum, and vital twentieth-century material has come from the increasingly important collection at the Centre for the Study of Cartoons and Caricatures, at the University of Kent, Canterbury.

ACKNOWLEDGEMENTS

The four institutions participating in the exhibition record their gratitude to all the lenders, both private and institutional. The exhibition is greatly enhanced by generous loans from the exceptionally choice collection of Allan Cuthbertson, and from Andrew Edmunds, who is not only London's leading dealer in the subject but also one of its best informed scholars.

They acknowledge an outstanding debt to Richard Godfrey, whose editing and writing of much of the catalogue reflects only a part of his contribution to the success of the venture. His co-organizer was John Riely, who selected most of the exhibits for those sections devoted to books and manuals, Hogarth, the amateurs, Rowlandson, the Golden Age and the Regency. Lionel Lambourne kindly agreed to select and catalogue the Victorian section. They have both contributed information about those parts of the exhibition for which they were chiefly responsible. The organization of the exhibition has rested with the staff of the Yale Center for British Art. Patrick Noon and his colleagues in the Department of Prints and Drawings, Scott Wilcox, Randi Joseph, Paula Joslin, and Leslyn Keil, have provided curatorial services, and Timothy Goodhue, Registrar, has handled all the practical arrangements involved in assembling works for the initial showing. Credit and thanks for the production of the catalogue are due to Michael Kauffmann, Keeper of Prints, Drawings, Photographs & Paintings, at the Victoria and Albert Museum, and to Nicky Bird, Publications Manager there. Lucia and John Woodward of the South Leigh Press have made an enthusiastic and crucial contribution to the publication.

Richard Godfrey and John Riely acknowledge their gratitude for research grants

from the Swann Foundation for Caricature and Cartoon, which were of great material help. At the Library of Congress, Bernard Reilly, assisted by Terri Echter and Mary McClean, readily provided research facilities and assistance. He and his colleagues Carol Nemeyer, Dana Pratt and William Miner have shown great enthusiasm for the project as have Catherine Jestin and Joan Sussler at the Lewis Walpole Library, and Mimi Cazort at the National Gallery of Canada, Ottawa. Particular thanks are due to Robert Rainwater at the New York Public Library, Jim Schoff at the Centre for the Study of Caricature and Cartoons, University of Kent, and to Draper Hill, who have fielded many enquiries. At the Royal Archives, Windsor Castle, Jane Langton kindly provided facilities for research. Christopher White and his staff at the Paul Mellon Centre for Studies in British Art, have helped in many ways great and small. Brian Allen, Assistant Director there, has answered a number of enquiries and also suggested the possible attribution to Mercier of *The Singing Party* (no. 34). The organizers also wish to express their gratitude to the following, who have assisted this project in various ways: David Alexander, Anthony Anderson, Rosemary Baker, Thomas Beecher, Steve Bell, Diana and Peter Benet, David Bindman, Elyse Bloom, Mark Boxer, Patricia Crown, Jean Duthie, Wally Fawkes, Ruth Fine, Margaret Galliano, Bill Greenfield, Antony Griffiths, Tonie and Valmai Holt, John Jensen, David Kiehl, Sir Osbert and Lady Lancaster, Louise Lippincott, Paul Magnusson, Michael Marsland, Thomas J. McCormick, Bruce Robertson, Gerald Scarfe, Ronald Searle, James Sherry, Lindsay Stainton, Ralph Steadman, Rob Stewart, Kerry Sullivan, John Sunderland, Joseph Szaszfai, Robert Wark, Diana Willis, and Andrew Wilton.

Most importantly, thanks are due to Gillian Singer and Beth Riely, who have had to live with the subject.

Permission to reproduce works comes from the Library of Congress, the Metropolitan Museum of Art, the National Gallery of Art, Washington, New York Public Library, the Pierpont Morgan Library, the Victoria and Albert Museum, the Lewis Walpole Library, Yale University, and the Yale Center for British Art, Paul Mellon Collection. Thanks are due to private owners for permission to reproduce works in their possession.

Drawings by Sir Osbert Lancaster, Gerald Scarfe, Ronald Searle, Ralph Steadman, and Steve Bell, are copyright of the artist. The Ronald Searle medal of Edward Lear is the copyright of Administration des Monnaies et Médailles, Ministere de l'Economie et des Finances de la République Française. Permission to reproduce drawings by David Low comes from Express Newspapers Ltd, and the drawing by Graham Laidler ('Pont') is reproduced by permission of *Punch*. Leslie Illingworth's drawing is reproduced by permission of *Associated Newspapers*, London.

INTRODUCTION

In about 1795, in a Letter to the Dilettanti Society, that most ambitious of history painters, James Barry, complained that 'With respect to the arts, our poor neglected public are left to form their hearts and their understandings upon these lessons, not of morality and philanthropy, but of envy, malignity, and horrible disorder, which everywhere stare them in the face, in the profligate caricatura furniture of print-shops, from Hyde-Park Corner to Whitechapel. Better, better far, there had been no art, than thus to pervert and employ it to purposes so base, and so subversive of everything interesting to society.'

His anger was mixed with jealousy, for the 'poor neglected public' had little taste for history painting, but a vast relish for the brightly coloured caricatures which were at their most vital in England in the closing years of the eighteenth century. The art was considered as British as roast beef and beer, a manifestation of Liberty denied to the beggarly French. It added a third dimension to the national school of portraiture. Public figures, the rich and the fashionable, could sit to Reynolds or to Lawrence, and might settle their bones under towering edifices of monumental statuary, but first they must run a gauntlet of caricaturists, their ambitions derided, their persons abused, their moral failings exposed.

Mockery of the individual was but one function of caricatures. Barry's theme in his great paintings for the Royal Society of Arts was the *Progress of Human Culture*. The theme of the caricaturists was the progress of folly, of greed and lechery, often embodied in the corruption of such professions as the Army, the Church, Law and Medicine. Added to this was humour of the simplest kind: hen-pecked husbands and stout wives, drunkards, and, to the English, the eternally ridiculous spectacle of the foreigner. The content of caricatures ranges from original and passionate statements on high politics to the vulgar farce which is still familiar today. Yet ironically, while for Barry the pursuit of the Grand Manner was a self-imposed *via dolorosa*, the spirit of the Grand Manner, the epic and the Baroque, was most naturally expressed in England by the burlesque. Gillray's most elaborate compositions not only puncture the pretensions of Royal Academicians to High Art, but also scramble naturally into an imaginative world which was denied them. The instinctive mingling of the recognizable with the fantastic which characterizes Gillray, Rowlandson, and even James Sayers, provided the most appropriate mirror to the historical drama of their times, and is a vulgar curtain-raiser to the Romantic period.

By the 1790s visual satire was old, but the art of personal caricature, seemingly as natural an activity as mimicry of voice and gesture, was still new. It consists of the graphic distortion of the salient points of a person's appearance or habitual costume so as to excite amusement or contempt. If they have no salient points, then some must be invented to create an agreed fiction. A tendency to fatness can thus be enlarged to elephantine proportions, or to the image of an elephant itself; a prominent nose to an interminable appendage. This mode of drawing was first practised by Annibale and

Agostino Carracci in Italy at the end of the sixteenth century, and it was another 150 years before it was adopted by satirists in England. Annibale Carracci is even credited with a lucid definition of the art:

'Is not the caricaturist's task exactly the same as the classical artist's? Both see the lasting truth beneath the surface of mere outward appearance. Both try to help nature accomplish its plan. The one may strive to visualise the perfect form and to realise it in his work, the other to grasp the perfect deformity, and thus reveal the very essence of a personality. A good caricature, like every work of art, is more true to life than reality itself.'

Or, in the words of Mrs. Lammle in *Our Mutual Friend* when looking through portraits with Mr. Twemlow: 'So like as to be almost a caricature?'

The state of the art at the end of the eighteenth century represented the successful grafting of caricature onto an older emblematic tradition which had flourished since the early seventeenth century. However, the earliest English satires are usually more of antiquarian than visual interest, and reflect the poverty of early English print history. Influenced by the convoluted imagery of emblem books they reveal little interest in the idiosyncrasies of individual appearance, and even less in humour. Significantly, one of the first major English satires, or polemical prints, was *The Double Deliverance* (no. 1) of 1621 which was designed by a clergyman, the Ipswich preacher Samuel Ward. Like many succeeding prints it has the air of a sermon, based on unswerving dogma. Its vehement anti-Catholic posture is typical of many prints throughout the century, which are visual counterparts to the inflammatory cry of 'No Popery'. Nor did this theme expire in later centuries; it was restated in epic terms by James Gillray, especially with reference to Ireland, and in 1850 Richard Doyle, a Catholic, felt obliged to resign from *Punch* because of that magazine's virulent anti-Catholic stance.

Production of satires in the seventeenth century was sporadic, rising to peaks at times of crisis such as the prelude to the Civil War, and the so-called Popish Plot of 1679. In the first case they were complementary to the crude broadsides which each side flung at each other, echoing their use of imagery, and sometimes relying on extended inscriptions. They still had the power to harm; Archbishop Laud, later to be executed, complained of '. . base pictures . . . putting me in a cage and fastning me to a post by a chaine at my shoulder. And divers of these libels made men sport in taverns and ale-houses, where too many were as drunck with malice as with the liquor they sucked in.'

Throughout the century few prints were signed, and their design is generally such as to preclude much curiosity about their authorship. However, a handful of superior satires by Wenceslaus Hollar are known (no. 2) and in the latter half of the century it is now possible to identify Francis Barlow, the illustrator and animal painter, as the designer of a number of anti-Catholic prints such as *The Happy Instruments of England's Preservation* (no. 4), as well as sets of playing cards with political designs. But these artists are the exception to the production of designs with figures stiffly arranged and poorly drawn. From the time of Cromwell the best satires on English affairs were by Dutch engravers, culminating in the superb baroque designs of

Romeyn De Hooghe, attacks on James II etched at the instigation of William of
Orange as he prepared to replace that Catholic monarch on the British throne. They
anticipate the drama of Gillray's prints, and at least one Englishman, the otherwise
obscure William Loggan, was astute enough to enlist his services for an attack on
Father Peters, the Jesuit confessor of James II (no. 5).

Dutch and English interests coincided again with the spectacular stock-exchange
disasters of 1720, notably the South Sea Bubble, which attracted many Dutch satires,
as well as two effective but rather old-fashioned prints by the young William
Hogarth. Many of the Dutch prints, with their atmosphere of urban excitement, their
lively mixing of the allegorical with the actual represent something of a territorial gain
for the satirical print. First published in Amsterdam, and copied in England with the
title *A Monument Dedicated to Posterity* (no. 6), Bernard Picart's design mixes
emblem with genre as a juggernaut of Speculation is driven by Folly and followed by
a greedy mob. Such a print prepares us for the Hogarthian world, for his
condemnation of moral vice and folly, but also for his delight in the spectacle of the
human character in extremes of behaviour.

Hogarth is the first English artist to work on the same intellectual level as writers
such as Defoe and Swift, and inevitably his work dominates the whole period until his
death. Politics continually intrude in his work, but he engraved few specifically
political satires, although such subjects were the main sustenance of many fellow
engravers. The heart of his work lies in the series of paintings, popularized by his
engravings, such as *The Harlot's Progress, The Rake's Progress* (no. 29) or the later
Election Series (no. 32). In *The Rake's Progess* an individual's course to ruin is set
against a scrambling cast of characters, the streets, salons, and prisons of London
providing the potential juxtaposition of every conceivable human type. This was a
gallery of types that was immediately pillaged at will by contemporary satirical
engravers, and those who were to follow. The scrawny Frenchmen of *The Gate of
Calais* (no. 31) are the direct ancestors of Gillray's starving Frenchman in *French
Liberty – British Slavery* (no. 100), and *Beer Street* provided a blueprint for the
Englishman's ideal of prosperous, beer-drinking contentment. Hogarth's influence
was not confined to his engravings; his professional ambition, the energy with which
he agitated for the Copyright Act of 1735 increased the prestige of his profession, and
enlarged its possibilities. A great satirist, Hogarth has also been frequently dubbed
the 'father of English caricature', although, as events were to prove, he was a
decidedly reluctant parent.

Hogarth's political satires are not amongst his best works, and, in the case of *The
Times. Plate I* (no. 33) exposed him memorably to delighted mockery by other artists,
notably Paul Sandby. But the efforts of his contemporaries in this field are too often
ignored, for their industry resulted in an increase in the quality and quantity of
satires, especially in the 1740s, that included a number of images to rival the better
known prints of the later 'Golden Age'. Like earlier prints they are often laden with
emblems and verbiage aimed at a small but knowing audience, who required a solid
substance of allusion and detail on which to chew and ruminate. Many were carefully
engraved, usually by artists who were also engaged in other forms of work, and their

mode of execution generally prevented a rapid response to events. Usually uncoloured, often with figures arranged across the surface as on a stage, they seem austere in comparison with later caricatures. Their imagery can be gross and scatological; Ministers of the Crown defecate, vomit up their ill-gotten gains, disperse their enemies by monstrous farts, and grovel for money like hungry mongrels. These prints do not reflect political balance; the majority are predictably from an Opposition point of view, the long Whig administration of Sir Robert Walpole attracting many prints (nos. 38, 39, 41).

The increase in the vitality of satires in the late 1730s and 1740s may be seen, at least in part, as a reaction against the dried up conventions of the early eighteenth-century portrait, dull mezzotints from which clogged the print-shops. The smug, bewigged faces, uniform in feature and pose, and backed up by hackneyed props to suggest sagacity, rank, and virtue, were a standing affront to the satirist's art. Thus, if Hudson makes Handel look like a statesman, then Goupy depicts him as a hog; Kneller's Alexander Pope is a soulful aspirant to higher things, but Gravelot's version is a libidinous hunchback; the Robert Walpole of Kneller or Van Loo is responsiblity embodied, but an anonymous satirist makes him bare his buttocks to be kissed by a toadying placeman (no. 38).

Throughout the century satirists formed an irregular society for the encouragement of xenophobia, and the real or imagined abasement of British ministers before foreigners, especially the French and the Spanish, is a continual theme. Britannia is shown weeping and abused, the British lion or bull supine before scheming and vulpine Frenchmen. A traditon of using animals as metaphors for countries was now well established, although this menagerie of nations had not yet acquired the finality and fixed order that characterizes the Victorian period. The Dutch, because of their damp country, were the frogs rather than the French, who were often represented as monkeys. Mosley's *The European Race* (no. 37) makes particularly sophisticated use of animal imagery, while the anonymous *Locusts* (no. 43) is an enduring image of bureaucratic exploitation.

Many prints in the first half of the century were anonymous, and an unusual flurry of Government activity in 1749, following the publication of *John of Gant in Love*, a satire on the Duke of Cumberland's morals, showed the wisdom of this. Engravers and printsellers, fearful of prosecution, scuttled for cover like rats, disclaiming all knowledge of the offending prints. Yet a number of consistently interesting artists can be identified, including Charles Mosley, the productive George Bickham the younger, L.P. Boitard, who specialized in social subjects, and Anthony Walker. Some of the best satires were by men who rarely affected the genre, such as Joseph Goupy and Gravelot, while Paul Sandby, a founding figure in the English watercolour tradition, was a great satirist manqué, who never drew with more vivacity than in his attacks on Hogarth (nos. 50, 51).

If the practice of caricature, the Italian art, was unknown in England before the 1740s, then the word itself had been circulating for some time. In 1710 the Duchess of Marlborough is reported to have said to Bubb Dodington: 'Young man, you come from Italy, they tell me of a new invention there called caricature drawing. Can you

find someone that will make me a caricature of Lady Masham describing her covered with running sores and ulcers that I may send the Queen to give her a slight idea of her favourite.' A few caricatures had been made in England by Marco Ricci and the amateur Anton Maria Zanetti, but it was Arthur Pond's etchings after Pier Leone Ghezzi's caricature portraits that first properly introduced the English public to the art of personal caricature. These formed twelve of the twenty-six prints from Italian caricatures, the others being from earlier masters (no. 7), which Pond produced between 1736 and 1742. That they became modish and were much discussed is proved by Hogarth's prompt and ill-tempered response in *Characters and Caricaturas* (no. 30). He saw them as fashionable playthings for the amateur, infantile distortions which needed no executive skill or thought. More importantly he resented the imputation that *he* was a caricaturist, rather than a highminded student of character.

From 1742 many British visitors to Rome must have been aware of caricature, and Ghezzi in particular, although he drew only a handful of British visitors to the city. One of his subjects the Irishman Joseph Henry (no. 8) was evidently an enthusiast for the art, for he was also the original purchaser of Joshua Reynolds's celebrated parody of *The School of Athens*, in which British tourists replaced the stately figures of the original. Reynolds had arrived in Rome in 1750 and stayed there for two years in earnest study of Italian art. In this context his handful of caricature groups of British and Irish visitors to the city formed a light-hearted diversion from the intellectual rigours of his daily programme. For Thomas Patch it was an extended professional activity, and from 1755 when he moved to Florence, it was an item on the itinerary of many British tourists to be included in one of his caricature groups of which the *Golden Asses* is the most ambitious. He was an argumentative man, and his work is not without a certain waspishness, but as with Reynolds's pictures the essence of the activity was that the joke was shared. Artist and sitter combined in a conspiracy of mutual facetiousness that argued a degree of sophistication beyond the dullards at home. It was neatly defined in a letter of 15 August 1775 from Geoffrey Bagnal Clarke to his friend James Boswell, then in Florence, about a picture which is now lost: 'Patch has by this time encanvass'd you, and I dare say has made us as ridiculous, as his Genius will admit of. After all 'tis absurd enough for a man to sit seriously down to be laugh'd at, in a copy of his figure, who at the same time wou'd cut one's throat for laughing at the original.'

No such good fellowship motivated George Townshend, who introduced caricature to political prints, and whose drawings and etchings were the result of malice and spite. An army officer from 1743, he served under the Duke of Cumberland, for whom he developed a deadly antipathy, temporarily resigning his commission in 1750 and devoting himself, both in Parliament and in caricatures, to attacks on the Duke. Horace Walpole, a keen observer of caricatures, noted that he began 'to adorn the shutters, walls and napkins of every tavern in Pall Mall with caricatures of the Duke and Sir George Lyttelton, the Duke of Newcastle and Mr. Fox.' In 1756 he introduced a new format; small etchings printed as cards, and published by the Darlys, in which brevity and immediate impact was his intention. Larger in size is his most famous print, *The Recruiting Serjeant* (1757) (no. 49) which although clumsily

drawn, performed the necessary function of blending caricature with the emblematic conventions of existing satires, although it was some time before his lead was followed.

Townshend was the first amateur to convert a sophisticated private amusement into a rancorous public activity. The participation of socially elevated amateurs in drawing caricatures, or in paying artists to execute their ideas, was to remain significant throughout the century. Some of Gillray's most entertaining prints were produced from amateur designs or ideas (no. 77). One reason for the Establishment's tolerance and enjoyment of Gillray and his conferêres was that the educated public had grown up with the art and participated in its development. It was accepted as a corollary to the back-biting of the salons, and the denigrating gossip of Westminster corridors.

Townshend's political prints were an exception to the amateur's general preference for social humour. In this they were catered for eagerly by Matthew Darly and his wife Mary, engravers, print sellers and publishers, who were very active in the 1750s and 1760s, initially with political prints — especially against Lord Bute — and latterly with social satires. Matthew Darly enticed the amateurs in fulsome terms, but specifically discouraged political prints. 'Ladies and Gentlemen sending their designs may have them neatly etch'd and printed for their own private amusement, or for publication shall have every grateful return and acknowledgement for any comic design. Descriptive hints in writing (not political) shall have due Honor shewn them & be Immediately Drawn and Executed . . . ' An art thus available to all, it was in Mary Darly's words, suited to 'keep those that practise it out of the Hipps and vapours.' Most celebrated of the amateurs was Henry William Bunbury, whose mild social satires were engraved in abundance, attracting absurdly exaggerated praise. His drawings were given sharper form by the engravers, while a knowledge of Bunbury's gentility helped to increase the plaudits of a genteel audience.

The activity of amateurs contributed to a great increase in the production of social satires in the early 1770s and thereafter. This development was also stimulated by public fascination in the spectacle of the Macaroni, who went to ludicrous extremes in their foppish costume and behaviour. Only a footnote to a footnote in the history of costume, they yet formed the subject of hundreds of prints, as did the towering hairstyles affected by fashionable women at the same period (nos. 58, 61, 62). The setting for many prints is the teeming street life of London, where a Macaroni could be humiliated by a fruitwoman (no. 56) or a posturing Frenchman soundly drubbed by a sailor.

Social satires, supplied first by John Collet (no. 54) and then in abundance by Robert Dighton, under the title of 'postures', formed an important part of the stock in trade of Carington Bowles, who from 1767 was established at 69 St. Paul's Churchyard (no. 15). Dighton's watercolour shows his window mainly taken up by caricatures, but with a space reserved for portraits of popular preachers. Such displays were the outward sign of the prosperity of the trade in its heyday from about 1770 to 1832. Our knowledge of the details of the trade is based on hints and isolated facts. In the early years of the century an average price for a print was sixpence plain,

a shilling coloured. By the end of the century this price for a coloured print had generally doubled, although in 1807 Thomas Tegg started a business aimed at a popular market, selling crudely coloured prints for a shilling. In the eighteenth century however, new prints were clearly beyond the pockets of most of the population, who had to content themselves with the window display, or crude woodcut copies.

The number of impressions taken from a plate must have varied enormously, from a few dozen to several thousands. Hogarth's plates are authenticated best-sellers; George Vertue noted with admiration in 1732 that while the plates of the *Harlot's Progress* were being engraved 'he had in his subscription between fourteen and fifteen hundred'. The printer assured him that 1240 sets were printed. Hogarth represents the top end of the market, and of course his plates survived him, being continually re-touched and reprinted until they produced little better than grey ghosts. During the First World War a large number of the surviving plates were melted down so that their copper could be used for bomb-fuses — a fate that the xenophobic Hogarth might have appreciated. Many social satires by their nature could expect a long life, since their meaning was not quickly obscured, like political prints. Besides inheriting many old plates, Bowles also believed in getting the maximum life from mezzotints, their wear being disguised by the heavy application of colour. By the 1770s hand colouring was common, reflecting a general increase in the appetite for coloured prints; by the 1790s it was almost standard practice. Hand-colouring was usually crude but effective, applied rapidly by low paid assistants, but in the case of the more expensive Rowlandson's, and many Gillray prints, it was very skilfully executed.

In the last decades of the century numerous important print-publishers became established, although their monopoly was continually challenged by scores of minor printsellers or publishers who issued a few plates, or specialized in the work of a particular artist in the way that James Bretherton monopolized Bunbury's work. In 1782 the important William Holland opened an establishment, followed by S.W. Fores in 1784. Both for a while opened permanent exhibitions of caricatures, charging a shilling admittance, which, like the Royal Academy, was probably to 'prevent the Room from being fill'd by improper persons.' Fores advertized his stock as 'forming an entire Caricature History, political and domestic, of past and present Times.' And a service offered to collectors was the assemblage of volumes that would make a caricature history of Britain. Sale of single prints was only one possible transaction: Fores offered 'Folios of Caricatures Lent out for the Evening. Prints and Caricatures Wholesale and for Exportation; also prepared for Screens, assorted for Folios, and arranged for Scrap Books, etc, etc.' The sale of caricatures was not monopolized by these specialized shops; Ackermann had a large number in his varied stock, and the bulk of the Royal collection was bought from Colnaghi's. By 1792 however, the most important artist, James Gillray, could only be purchased from the well known shop of Hannah Humphrey. Export of prints was a significant factor — proved by foreign copies of English prints — but the main market was at home, and consequently the caricature trade did not suffer the slump which affected the rest of the trade when the Revolutionary wars closed much of the Continental market. War

was a positive stimulus to caricatures.

The shop windows were a mirror to the political and social preoccupations of the day. Macaroni prints overlap with a flood of prints concerned with the American Revolution, often favourable to the colonists and critical of the British Government and its army (no. 63). In many respects the English caricature came of age during the administration of Lord North, particularly when in 1783 he made his 'infamous' coalition with Charles James Fox. The trade was established, a generation of customers had grown up accustomed to the art, and the quick functional technique of etching had replaced engraving. A dynamic period of history was beginning, and a number of great caricaturists had started their careers. A procession of eminent subjects paraded before the eager artists, headed by Fox, hirsute and bulky, the leading Whig and the 'man of the people'. Warren Hastings, the Jesuitical Edmund Burke, Richard Brinsley Sheridan, all inspired enough prints to fill separate volumes, while the lanky William Pitt would require several.

In the early 1780s the most important artist was James Sayers, who from 1781 etched some spirited attacks on the Whigs, and on Fox in particular. Crudely drawn and etched, his prints nonetheless reveal an acute sense of drama, buttressed by apt quotations from Milton and other writers. His figures fill up the picture space boldly, and his use of the mock-sublime, employed appropriately to attack the endless rhetoric of Burke (no. 95) was a potent legacy to Gillray.

Gillray is the heart of the matter. His early career as a caricaturist was interrupted by his efforts to establish himself as a reproductive engraver. Not until 1788 when he had been etching caricatures for more than ten years, did he actually sign one, since a reputation as a graphic wit was not likely to advance his career as an engraver. Yet the discipline of reproductive engraving may be seen as a barrier against which his inventive genius, like that of his contemporary William Blake, pushed and swelled until it burst through in a torrent of ideas. The comparison of Gillray with Blake is not new, but it is worth making it again, since they represent two opposite poles of English imaginative art. Blake's world is one of idealized figuration, released from the shackles of the life-room and wrestling with moral conundrums in a symbolic world. Gillray's is one of gross corporeal contrasts, of contemporary figures glimpsed on the streets, or sketched furtively from the gallery of the House of Commons. Blake's figures disport themselves in a cosmic universe, or ramble amongst enchanted woods; Gillray's creations gorge themselves, sprawl or fly with grotesque vitality. Blake hated Rubens; Gillray adored him, and in his last years he even told the young George Cruikshank that he *was* Rubens. Many of Blake's contemporaries thought that he was a madman; he was not, but the last years of Gillray were shrouded by hopeless lunacy.

From 1783 to 1785 he etched hardly any caricatures, but then returned to them with a relish, and with extraordinary technical powers. A principal target was the Royal Family, who feast on 'John Bull's Blood' in *Monstrous Craws* (no. 96). The spectacle of figures cramming food into their mouths is one that Gillray always viewed with dyspeptic disgust, and the ravenous Queen Charlotte is here almost a prototype for the *sansculotte* in *French Liberty – British Slavery* (no. 100). Gillray

often carries an idea or a form from one print to another, and the thrusting motion of the Queen's body is inherited by the popinjay officer in *A March to the Bank* (no. 97). His love of the baroque is evident here, and like his friend Rowlandson, Gillray never drew with greater ebullience than in the five or six years from 1786. Even more than Rowlandson he is prepared to subject the human form to extreme distortions, to snap a leg at the knee to get an extra curve, or taper a woman's waist to a sharpened point. An acute observer of reality, Gillray also reserved a sharp eye for pictorial sources that he could convert to his own purposes. Thus the 'mad taste' of Fuseli is pressed into service in *Wierd-Sisters* (no. 98) an exercise in the 'caricatura-sublime' and *French Liberty – British Slavery* is derived ultimately from Pieter Brueghel's famous prints *The Poor Kitchen* and *The Rich Kitchen*.

In 1789 Gillray's career, like that of many other caricaturists, was given added focus by the events of the French Revolution, which rapidly polarized political opinions. As violence increased, culminating in the guillotining of the King and Queen in 1793 and the beginning of the long war with Britain, so did Gillray turn his attention to the devilry of the Jacobins, and their supposed sympathisers in Britain. From 1795 he was in close contact with young Tories like George Canning and his friend the Rev. John Sneyd, who suggested ideas, and tried to mould Gillray to their purposes of propaganda. By 1797 he was for a while, like James Sayers before him, in receipt of a Tory pension. Fox was assailed mercilessly in such prints as *Stealing Off* (no. 103) and continually frustrated in his fell designs by the beanpole figure of Pitt (no. 108). John Bull, depicted by Gillray as a slovenly but knowing farm yokel, is pulled between the two, pressed for his money by Pitt, and enticed by Fox with empty promises. Gillray anticipates the modern cartoonist by inventing types, and conceptions of individuals, which can be used again and again in different circumstances, giving continuity to the separate prints as they appeared. So well defined do the types become that they can be presented as fragments, seen from behind, or with only the tip of nose showing from behind a pillar, yet still instantly recognizable. George III, seen almost as a superior species of John Bull appears regularly, although seldom attacked with the violence Gillray reserved for the reprobate Prince of Wales. Napoleon is reduced to a vainglorious urchin, his pretensions buttressed by the hero-worshipping pictures of Jacques-Louis David, but parodied by Gillray in the *Grand Coronation Procession* (no. 106).

He did not confine himself to politics; fashionable exquisites and society figures occupied his attention equally, as did charlatans, or great connoisseurs like William Hamilton or Richard Payne-Knight (no. 101). His malicious interest in London's art world is revealed by the sumptuous *Titianus Redivivus* (no. 102) in which the follies of the Royal Academy are displayed. This print also reveals how much Gillray remained his own man, for the imagination and labour involved in its execution can only have been rewarded by a comparatively small and specialized audience.

Gillray's work accommodates the most refined stippling with brutally gouged lines and bright colours, but even his output does not touch the extremes of Rowlandson's. This ranges from exquisite watercolours, full of rococo curves, to coarse coloured etchings. He etched numerous political satires, particularly early in his career, but

neither politics nor printmaking are at the heart of his work, which is best expressed in watercolours, often elaborately worked up for exhibition, or in countless pen sketches. In thinking of Gillray we think also, by association, of Pitt, Fox, and other of his subjects. Rowlandson dealt rather with generalized types, who embody a particular human vice or represent an extreme of ugliness or beauty. A student of physiognomy, his pen was constantly exploring variations of profile, comparing a man with an appropriate animal, juxtaposing a lecherous old wreck with a young girl (no. 88), or a fat man with a lean one. His appetite for the grotesque was considerable, and he could pile up a debauched face with loathsome features and excrescences until the human likeness was almost gone. Ultimately his vision of the world is simpler than Gillray's, and his view of the human comedy more attuned to a basic English conception of the comic. Ladies tumbling in disarray down the *Exhibition Stare-Case* (no. 90), or naked fat men enduring the discomfort of *Dr. Graham's Earth Bathing Establishment* (no. 86) show Rowlandson at his most natural. Over a long career, when the pot had constantly to be boiled, it was inevitable that his vision and technique should coarsen. Its greatest flowering was perhaps in the 1780s, in such watercolours as *Place Des Victoires, Paris* (no. 83), but when his interest was aroused he never failed to produce a sparkling line or a memorable image.

Gillray and Rowlandson naturally overshadow their contemporaries, none of whom approached their ability even closely. Ramberg's few caricatures show their influence, and something of their skill in drawing, revealing also a knowledge of Mortimer, whose pen-work and love of the grotesque had a profound influence on both artists. Rowlandson had his imitators, notably John Nixon and Henry Wigstead, and Gillray his copyists, but the so-called 'Golden Age' is the result of innumerable contributions by humbler artists, often highly individual. Their very crudeness is often a strength: the barbed-wire lines of William Dent, which, in Henry Angelo's words, ' . . . though ill drawn, and miserably executed on copper, superseded many others, in public estimation for their sheer humour, and caustic wit.' (no. 113). Henry Angelo liked caricatures and caricaturists, and in his *Reminiscences* gives us many valuable vignettes of their characters: John Nixon, who '. . . could sketch a portrait, with a few scratches of his pencil, of a party whom he had not seen for twenty years, and with such marked traits of resemblance as to be known at a glance.' The central importance of London is shown in an anecdote of George Woodward, an immensely productive figure. 'A caricaturist in a country town,' said George, 'like a mad bull in a china shop, cannot step without noise; so, having made a little noise in my native place, I persuaded my father to let me seek my fortune in town.' Many other figures vie for our attention; O'Keefe, with his livid colours and Radical viewpoint (no. 121); John Cawse, cutting a narrow strip of copper so that he can attenuate Pitt's figure like a distorting mirror in *An Evergreen* (no. 127); the short-lived but brilliant Richard Newton, political and social satirist, whose *Scots Concert* (no. 119) is a definitive statement of national prejudice. The Golden Age is given its substance by Gillray and Rowlandson, but ultimately it is the sum of many parts, of a chorus of discordant voices.

In 1810 George III became permanently insane, and the Prince of Wales assumed

the Regency, until his ascent to the throne in 1820. The scandals of his private life provided continual entertainment for the caricaturists, rising to a crescendo of libellous prints at the time of the Queen's Trial in 1820 (nos. 142, 143). Hounded on every side, the desperate victim tried to buy his way out of trouble, spending over £2000 in attempts to suppress prints, by giving large sums of money to artists in return for their pledge not to caricature him in immoral circumstances. George Cruikshank pocketed £100 and was also paid expenses for his trip to Brighton to discuss the matter.

Cruikshank is the leading figure of the Regency, and a worthy successor to Gillray, whose old working table he bought as a mark of sentimental esteem. The son of an outstanding caricaturist, Isaac Cruikshank, he was brought up to the trade and had soon acquired extraordinary facility in drawing and handling the etching needle. His appetite for the comic-grotesque, and the agitated movement of groups of people, is used to chronicle the disastrous retreat of Napoleon from Russia (no. 130), and the accumulation of comic incident in *Inconveniences of a Crowded Drawing Room* (no. 132). With his brother Issac Robert, he squeezed the last ounce of fun from the spectacle of the dandies, but could also reveal a sterner side in political prints. His large output of hand-coloured etchings were but a beginning to a career which became largely devoted to book illustration. A convert to the Temperance cause, he devoted some of his most sustained and serious efforts to graphic warnings of the dangers of the Bottle. Essentially there are two George Cruikshanks; the licentious reveller of the hand-coloured etchings before 1830, and the celebrated illustrator of the Victorian period, both united by a gift for animation which has scarcely been surpassed.

Production of prints throughout the 1820s was intense, rising to a peak at the end of the decade amidst threatening civil disturbances, and irresistible agitation for Reform. William Heath emerges as a major figure, with a particular gift for the strong presentation of a single figure, notably the Duke of Wellington. He was at the end of a long tradition, for the passing of the Reform Bill in 1832 was the last great subject of the outspoken coloured prints which had flourished for more than sixty years. Already by 1831 a writer in the Athenaeum could look back distastefully at Gillray as 'a caterpillar on the green leaf of reputation,' and by the time the young Victoria came to the throne it would have been almost unthinkable to subject a Cabinet Minister, much less a Monarch, to the coarse visual abuse which the eighteenth century had enjoyed and accepted. The appetite of the public had become more refined, and caricatures had become the preserve of magazines and papers. These had editors and editorial committees, well versed in the laws of libel, and aware that an image once printed was scattered beyond recall. The spirit of caricature now burnt most fiercely in France, where artists such as Daumier and Philipon picked up where the English had left off. It was a sign of the new ascendancy of the French that *Punch*, the embodiment of Victorian humour should have the subsidiary name of the *London Charivari*, taken from the French magazine.

John Doyle, who worked under the initials of 'HB', signalled the transition in his mild lithographs, the *Political Sketches*, which ran from 1829 to 1851. The very touch

of the lithographic crayon is here less abrasive than the deeply bitten lines of the etcher. The time was not far off when caricaturists, working under the new name of cartoonists, would receive knighthoods, an elevation unthinkable for the likes of Gillray. However, one man at least fought hard against this move into respectability: the obscure and bad tempered figure of Charles Jameson Grant. A violent Radical, with Anarchist sympathies, he launched himself at the throat of the Establishment first with etchings, then with lithographs, and with the broadsides of the *Political Drama*, crude cheap woodcuts which have all the subtlety of smashed window panes. He reserved special hatred for the clergy and the newly founded Metropolitan Police (nos. 153, 154). But Grant was out of time and out of place, and he gradually fades from view.

He contributed at least one rather insignificant drawing to *Punch* and in its early days the magazine had a Radical spirit. Founded in 1841 and still flourishing, *Punch* is the medium through which succeeding generations have gained many of their conceptions about Victorian life and humour. It was one amongst many satirical journals, but its longevity, and the consistently high level of its artists in the nineteenth century give it a central position. The sprightliness of its early numbers owed much to Richard Doyle, not only through his large drawings, but through the marginalia and decorations with which he enlivened its pages. With his departure in 1850, in protest against the magazine's virulent anti-Catholicism, its design becomes more predictable. A full-page political cartoon, the weekly 'big cut' was followed by numerous other wood engravings, usually small drawings of social humour. Many of the early political cartoons were the work of John Leech, and were frequently astringent in tone, in contrast to the merriment of his hunting scenes and other drawings. Their clarity, sharpened by translation into wood engraving, and the considered allegory of their designs set a standard which endured for years.

When he died in 1864 he was succeeded by John Tenniel as main political cartoonist, a task he fulfilled until his retirement in 1901. His cartoons have most frequently attracted the description of 'dignified', a fact of which he complained bitterly, as he considered many of them to be very funny. He was, after all, the brilliant illustrator of *Alice in Wonderland*, with a real feeling for bizarre imagery, especially when he combined the animal world with the human. Many are intended as a kind of history lesson, in which the British Lion dominates the beasts of other nations, while John Bull and Britannia represent Truth and Justice in the face of their opponent's falsehood. John Bull has come up in the world since the time of Gillray's bemused peasant; prosperous, with gleaming boots, he shakes foreigners by the scruff of the neck, rebukes malcontents, and speaks sternly to errant politicians. Mr Punch himself frequently appears in the cartoons, often with the same function of a stern observer. Although designed and executed by Tenniel these were editorial cartoons expressing the views of the *Punch* Table. A memorial essay in *Punch* in 1914 recalls that ' . . . he did not at the Punch Table take a leading part in the discussion of the preparation of the cartoon for the following week. He listened closely, and when the picture came out those who had contributed suggestions to its form perceived how by some subtle touch of humour or fancy Tenniel had improved upon them.'

This was a method still employed in the 1950s. Anthony Powell recalled in his memoirs *To Keep the Ball Rolling* that Leslie Illingworth 'liked to be instructed down to the smallest detail as to what he should draw (directions that he would follow with consummate attention, always adding a certain development of his own)'. This editorial system is one explanation for the continuing use of a well defined style, and the extended employment of the main artists; it allowed the Table a library of existing images and metaphors, a predictable language which they could use to express an editorial view.

Tenniel's manner was continued by Bernard Partridge and Raven-Hill, although his immediate successor, Linley Sambourne, had a more distinctive and succinct manner of drawing (no. 169). Tenniel had relied almost exclusively on photographs to obtain his likenesses, and Sambourne made an even more extended use of this practice. A more vivacious use of personal caricature, giving a greater impression of actual observation, was made by Harry Furniss, particularly in his memorable drawings of Gladstone in an enormous collar (no. 173). The political cartoons were intended for the serious cogitation of *Punch* readers, before they were diverted by the lighter humour of the other drawings. Charles Keene, Du Maurier, and Phil May were foremost amongst the draughtsmen whose social humour provides incomparable glimpses into the lighter side of Victorian life and manners.

Punch did not monopolize all the best artists, nor corner all the possibilities of humorous drawing. Edward Lear's *Book of Nonsense* was published in 1846, and his whimsical humour, and deliberate use of a spare, pseudo-naive style of drawing has retained its sparkle when many other artists have long since ceased to amuse. Caricature has often provided a diversion for otherwise high-minded artists. Burne-Jones took refuge from his fey dreams of the Middle Ages in rapid caricatures, including some of friends such as William Morris (no. 168). By the 1880s, when *Punch* was an established institution, the time was ripe for the noisy entrance of 'Ally Sloper', whose misadventures drawn by Baxter for *Ally Sloper's Half-Holiday* have a refreshing smack of vulgarity, and a vitality which anticipated the modern comic (no. 172).

Vanity Fair was founded in 1868, and inclusion in its long series of portraits was essential for any Victorian or Edwardian with claims to social or professional eminence. The element of caricature in most of them is mild, or non-existent, although Leslie Ward's ('Spy') portrayal of Anthony Trollope was sufficiently disrespectful to offend its subject. *Vanity Fair*'s portraits include a handful by Max Beerbohm, the finest caricaturist to appear in England for nearly a century, and a wit in the class of Oscar Wilde or Whistler. At his best in the 1890s and the Edwardian period, when his caricatures of the King had a disrespect not shown for decades to a crowned head, he eschewed the high finish of *Vanity Fair* drawings for the simplified use of elegant distortions. Politics did not interest him. He was entranced by the self-regarding world of art and letters, which he observed with exquisitely ironic detachment. The conceit of Shaw, the drama of the Victorians at whom he looked back with delight, the portentous dreams of H.G.Wells, were all deflated by the epigrammatic wit of his watercolours, or an accurate scratching of a few pen lines

(no. 171). Caricature has invited many definitions of its meaning and purpose; Beerbohm's is one of the most thoughtful, included in an essay of 1901, 'The Spirit of Caricature': 'The most perfect caricature is that which, on a small surface, with the simplest means, most accurately exaggerates to the highest point, the peculiarities of a human being, at his most characteristic moment, in the most beautiful manner.'

This was not a definition likely to impress the young Australian Will Dyson, who came to England in 1909 and began to draw large political cartoons for the *Daily Herald* in 1912. Dyson sought 'anything to escape from Charm and Humour, those interminable and devastating cross-talk comedians'. His rhetoric was angry, and his black and white contrasts of bloated capitalists and suffering workers have retained their appeal for socialist cartoonists ever since. His career was interrupted by the First World War, and his later work for the *Daily Herald* had lost something of his early power. The War temporarily united him in purpose with cartoonists of all political hues, as they lent themselves to the country's propaganda programme. The evils of the Kaiser, the Huns and the Turks, were displayed in countless drawings, their effect ultimately becoming blunted by constant repetition. The most famous cartoon of the War, Bruce Bairnsfather's *'Well, if you know of a better 'ole'* (no. 181) concentrates on the predicament of the British soldier at the Front, and its direct humour and inspired caption found an instant response amongst both soldiers and public.

The years between the wars are the great period of the popular press, its sales not yet disrupted by radio, much less television. When David Low arrived in London in 1909, there were nine evening papers in the capital (there is now only one) and the cartoonist could be a vital weapon in the circulation battle. His function was generally to support the editorial policy of the paper, which probably reflected the views of its owner, and to labour continuously, producing five or six drawings a week. The qualities required are demanding; the constitution of an ox, an unflappable temperament, a wide repertoire of visual ideas, and a journalistic knack for determining the main features of the news. The attention span of the average reader is limited, perhaps two or three seconds. The image must therefore be presented strongly in a manner that will stand out from the surrounding newsprint. There is little room for technical development and experiment; the momentum of the job requires the early creation of a workable graphic style which can be exercised with metronomic regularity. A Low drawing of the 1920s is indistinguishable in style from those he was making thirty years later.

David Low was the epitome of a political cartoonist, and also a skilled draughtsman of personal caricatures. A New Zealander, he came to England in 1919, and after working for the *Star*, he joined the *Evening Standard* in 1927. His origins allowed him a certain detachment of vision from the English social and political scene, and it is significant that the great proprietor of the *Evening Standard*, Max Beaverbrook, was a Canadian. The paper was Tory, and Low a Socialist, but he was allowed a completely free hand, Beaverbrook's own politics being expressed by Sidney Strube in the *Daily Express*. When Churchill complained that Low was a 'Communist of the Trotsky variety', Beaverbrook answered: 'I do not agree with Low. I have rarely done so. I do

not intervene with Low. I have never done so.' Thus licensed, Low embarked on his great series of cartoons, their heart lying in the drawings of the 1930s with the rise of the Dictators and the politics of Appeasement. Low mingled his cast of actual characters with fictional ones, notably Colonel Blimp, who, armed with a loofah, and clad in a bath towel, gave voice to his absurd aphorisms. A burr in the side of the Establishment, Low was never far from controversy, but he was even-handed in his mockery. The hide-bound nature of the Trade Unions was symbolized by the lumbering T.U.C. carthorse, his other most celebrated invention.

Few political cartoonists have approached Low's standards and acute political intelligence. The traditions of the Beaverbrook Press have been continued by Michael Cummings in the *Daily Express* who expresses Conservative views in a clear and intelligent style. Beaverbrook did not garner all the best artists. For the *Daily Mail*, Leslie Illingworth regularly produced drawings of great clarity, and a rather detached vision (no. 193), and he performed an additional service by encouraging the young Wally Fawkes, who after many years still approaches his task with a crisp eye and a continually developing style of drawing. He has also broken ranks by caricaturing the Royal Family, who for most of this century have been a forbidden topic. In subjects of social humour, Graham Laidler ('Pont') and Osbert Lancaster, the latter in countless pocket cartoons for the *Daily Express*, have provided that observation of the passing whims and fancies of society that pins down historical footnotes otherwise forgotten. A friend and admirer of Beerbohm, Lancaster has also made some notable personal caricatures, such as that of Evelyn Waugh (no. 185).

In 1935 Low wrote in his brilliant book *Ye Madde Designer* that 'caricature, both in respect of personality and situation, is on the whole less inspired by caustic spirit than ever before in its history.' The foundation of *Private Eye* in 1961 did something to redress the balance, both in its journalism, and, especially in the 1960s, by its acceptance of drawings too barbed for other journals. In one notable issue, guest-edited by Malcolm Muggeridge, it savaged its predecessor *Punch*, Ronald Searle's outstanding drawing chronicling that journal's decline and fall. This was a case of dog bites dog, for Muggeridge was a previous editor of *Punch*, for whom Searle had provided many drawings. Searle's pen-work, describing with equal vivacity a grotesque face, or the façade of a building, has had a wide influence internationally. He acquired his skill the hard way, by the drawings he made in a Japanese prisoner-of-war camp, and since then has been enormously productive, particularly with social humour, observed in a variety of countries. A student of the history of caricature, his medals of caricaturists for the French Mint are a learned as well as a witty commentary on the subject (no. 197).

His work had some influence on the early development of both Ralph Steadman and Gerald Scarfe, who came to prominence at the same time in the early 1960s, their drawings appearing in *Private Eye* and other magazines. They have added a new and vigorous chapter to English satirical art by the very excess of their satire, by the violence with which their victims are stretched and distorted by bold pen-work on large sheets of paper. Whereas Low worked for reproduction, essentially as a brilliant graphic journalist, Scarfe and Steadman are often poorly served by reproductions

which reduce the scale and impact of their drawings. Personal caricature forms only a portion of Steadman's output (no. 199), and he is a draughtsman with a greater range of subjects than Scarfe. Recently he has concentrated more on illustration, including the books of J. Hunter Thompson, and his own books such as *I Leonardo* (1982). Scarfe too is developing in different ways, in large caricature sculptures, and in work for films and the Opera. But he still contributes caricatures to the *Sunday Times*, and personal caricature has been the substance of his career. His working process allows a drawing to develop gradually on the page, as he stretches a nose or expands Mick Jagger's mouth to a vast expanse of blubber. Hideous in subject, the line in such drawings is of outstanding quality, and is here reminiscent of Beardsley (no. 202).

These are difficult artists to follow, and it cannot be pretended that English caricature now flourishes with great originality. Too many artists are content to repeat themselves or imitate existing styles. So suddenly did the art develop and expand in the eighteenth and nineteenth centuries, that ultimately its history may seem like the growth of a monstrous plant that appeared overnight, flourished, but then failed to renew itself. Yet the subject by its nature is unpredictable, and the next twenty years will no doubt breed artists to renew this great English tradition.

Richard Godfrey, 1984

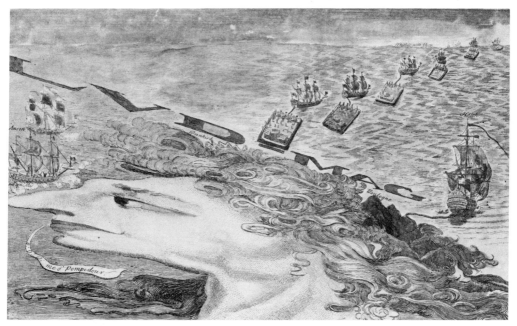

PL 18, CAT. NO. 44

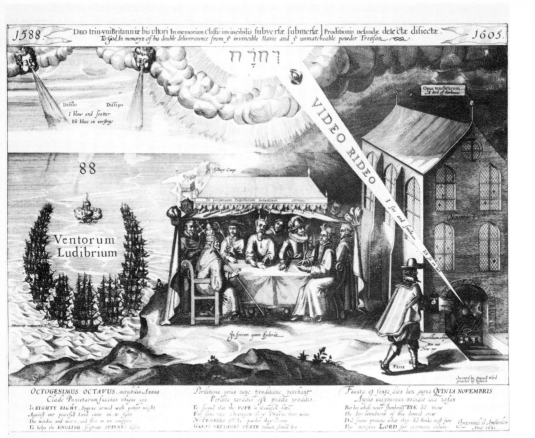

זִכָרָיֹ

VIDEO RIDEO

I see and smile

Difflo Diffipo
I blow and scatter
Ick blaes en verstroy

88

Ventorum
Ludibrium

Tilbury Campe

In perpetuam Papistarum infamiam

Opus tenebrarum
A deed of darkness

November

In foveam quam fecdcrut

Quærebllum abfint
Wor war
Now wre

Strururit inimicus Chs

Fäux

Jnventd by Samuell Ward
printdor by Ipswich

OCTOGESIMUS OCTAVUS, mirabilis Annus
Clade Papistarum faustus vbique nos

Perditione gerus nunc proditione petebant
Perfida veraditus est prodita proditis.

Fausta et festa dies lux aurea QVINTA NOVEMBRIS
Anglis victureram rediidit illa nefas

IN EIGHTY EIGHT, Spayne armed with potent might
Against our peacefull Land came on to fight
The windes and waves, and fire in on conspire
To helpe the ENGLISH frigehate SPAYNES desire

To second that the POPE in Counsell sits
For some rare stratagem they straine their wits
NOVEMBER 5th by powder they Deere
GREAT BRITAINES STATE ruinate should bee

But her whose never slumbring EYE did view
The dire intendment of this damned crew
Did soone prevent what they did thinke most sure
The mercyes LORD for evermore endure

Engraveld at Amsterdam
Ano 1621.

PL 1

The Infernall Conclave

PL 3

EARLY SATIRES AND THE INFLUENCE OF
ITALIAN CARICATURES

Satirical prints were rare in Elizabethan England, but increased in number in the seventeenth century, with peaks of production at times of crisis, such as the approach of the Civil War. Often elaborately engraved, they tend to be earnest and humourless, intended to inflame opinion and not to amuse. In the absence of personal caricature, figures were satirized by the absurd situations in which they were represented, and not by distortion of their features. Many were influenced by the elaborate symbolism of popular emblem books. Throughout the century a dominating theme is that of hostility to the Pope and Catholicism, seen as a continuing threat to Protestant England.

The art of personal caricature, the exaggeration of a person's characteristic features so as to excite amusement or contempt, was pioneered in Italy in the late sixteenth century by Annibale Carracci and other artists. By 1742 these had become known in England through engraved copies, as had the caricatures of the contemporary Pier Leone Ghezzi. It became fashionable for British visitors to Italy to be represented in caricature groups, such as the handful painted by the young Joshua Reynolds, and those by Thomas Patch who lived in Florence. The art was particularly fashionable amongst amateurs in England, but not until 1756 did George Townshend graft it onto the existing tradition of emblematic satires.

1 · SAMUEL WARD (1577–1640)

The Double Deliverance pl. 1

Engraving 33.0 × 51.7 cm. Pub. 1621 (BM 41)
Library of Congress, Prints and Photographs Division

One of the first major satires designed by an Englishman, the Ipswich preacher Samuel Ward, although it was printed and perhaps engraved in Amsterdam. It celebrates the deliverance of England from the Spanish Armada, and the failure of Guy Fawkes' attempt to blow up Parliament in 1605. Its publication was given additional point by the negotiations going on between England and Spain for the proposed marriage of Prince Charles and the Spanish Infanta. In a tent sit the Pope, the Devil, the King of Spain and others, plotting against England. The Spanish ambassador, Count Gondomar, complained that the print was calculated to inflame hatred against his countrymen, and Ward was brought to London to be examined by the Privy Council. The print foreshadows the bitter anti-Catholic strain of many seventeenth-century satires.

2 · WENCESLAUS HOLLAR (1607–77)

The World is Ruled and Governed by Opinion

Etching 33.4 × 24.8 cm. Pub. 1641 (BM 272). Andrew Edmunds Collection

Hollar's emblematic etching is a headpiece to verses by the Royalist poet Henry Peacham, which lament the large production of pamphlets and libels which preceded the Civil War, most of them being anti-Royalist. Broadsides and books grow like fruit on a tree, its roots watered by Folly. On its branches sits Opinion, a miniature Tower of Babel on her head, and a chameleon, the emblem of inconstancy on her hand.

3 · WENCESLAUS HOLLAR (1607–77) after LEONARDO DA VINCI (1452–1519)

(a) *Grotesque profile of a man wearing a hood* 1665, pl. 2
(b) *Two Grotesque Heads* 1645

Etchings. 6.9 × 5.2 cm, and 7.5 × 11.7 cm
Yale Center for British Art, Paul Mellon Fund B1983.28.1, B1983.28.2

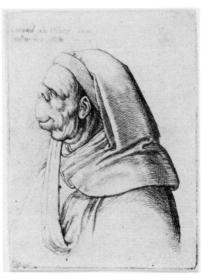

PL. 2

Leonardo's many drawings of grotesque heads are not caricatures, but a wide-spread knowledge of them through prints such as these, helped prepare the ground for the development of the art. The small print of a grotesque profile was copied as an example of caricature in Hogarth's *Characters and Caricaturas*. The best known copies are those by Hollar, who etched more than three dozen. He presumably copied

the originals when they were in the possession of the Earl of Arundel, who brought Hollar to England in 1636. The man in the pair of *Grotesque Heads* has sometimes been identified with Dante.

4 · FRANCIS BARLOW (*c.* 1626-1704)

The Infernall Conclave 1681, pl. 3

Pen and ink 17.2 × 24.8 cm. Pierpont Morgan Library, Peel Collection

The bottom half of a drawing for an engraved satire of 1681, *The Happy Instruments of England's Preservation* (BM 1114). The Pope and his agents plot against King Charles II and Protestant institutions. The upper half of the engraving shows Titus Oates and his supporters, the 'Instruments of Preservation', who had stirred up immense mischief by their 'exposure' of a so-called Popish Plot in 1678. Better known as an animal painter, Barlow is clearly the author of this hitherto unattributed satire, and he designed other prints and sets of playing cards to arouse anti-Catholic feelings.

5 · ROMEYN DE HOOGHE (1645-1708)
after William Loggan (active *c.* 1681)

Sic Itur Ad Astra, Scilicet

Etching 30.2 × 41.6 cm. Pub. 1681 (?) (BM 1118). Library of Congress

The identity of the Oxonian William Loggan is obscure, but he evidently sent his design or instructions to Holland, to be given form by the great etcher Romeyn de Hooghe. The main target is the unpopular Father Petre (or Peters) the Jesuit confessor and confidante of the Duke of York, later James II. He is seated at a table, his foot on the Bible, and looking towards Vanity while holding a mask before his face. The inscribed date of 1681 is puzzling, since Dutch prints attacking the Catholic James II and his circle were mainly published in 1688 when the King was forced to flee the country, being replaced on the throne by William and Mary.

6 · BERNARD PICART (1673-1733)
engraved by B. BARON (*c.* 1700-66)

A Monument Dedicated to Posterity in Commemoration of Ye Incredible Folly Transacted in the Year 1720 pl. 4 (detail)

Engraving. 19.1 × 34.3 cm. Pub. 1721 (BM 1629)
Library of Congress, Prints and Photographs Division

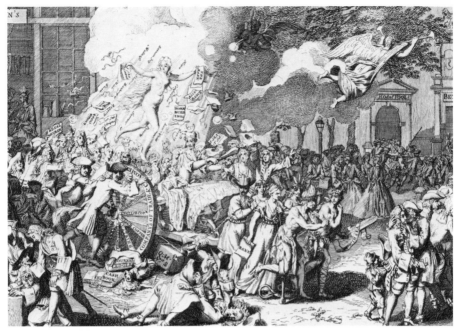

PL 4

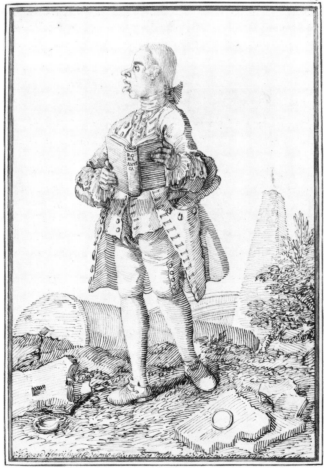

PL 5

An English copy from Picart's print with the inscriptions and some details changed. One of the most elaborate of many prints about the South Sea Bubble. There had been extraordinary speculation in the shares of the South Sea Company after its directors had taken over much of the National Debt. The 'bubble' burst in November 1720, ruining many speculators, although some made fortunes. Folly, in a fashionable hooped skirt, leads Fortune amidst scenes of greed and violence which recall Bosch's painting *The Hay-wain* and anticipate Hogarth's crowd scenes.

7 · ARTHUR POND (1701–58)
after ANNIBALE CARRACCI (1560–1609)

Due Filosofi c. 1736–40

Etching. 24.8 × 20.9 cm. Yale Center for British Art, Paul Mellon Fund, B1983.30

Annibale Carracci has always been credited as the first exponent of caricature, although hardly any such drawings can now be certainly attributed to him. Between 1736 and 1742 Pond produced two sets of prints after caricatures by Carracci, Ghezzi, Guercino and other artists, which were of great importance in familiarizing the English public with the style. Hogarth drew on these prints for examples of the 'debased' form of caricature in his print *Characters and Caricaturas*.

8 · PIER LEONE GHEZZI (1674–1755)

◁ *Joseph Henry of Straffon, County Kildare c.* 1750, pl. 5

Pen and ink 31.1 × 21.3 cm. Metropolitan Museum of Art, Rogers Fund

Ghezzi's caricatures, a number of which were engraved by Arthur Pond, were a vital means of introducing the art to England. He drew hundreds of Roman celebrities and visitors to the city, a very fine example being this archetypal image of a gormless but enthusiastic Grand Tourist, shambling about the ruins of ancient Rome with a large guide book in his hand. However, Joseph Henry enjoyed caricatures, and was the original purchaser of Reynolds's celebrated *Parody of the School of Athens*.

9 · SIR JOSHUA REYNOLDS (1723–92)

A Caricature Group 1751

Oil on canvas 62.8 × 48.3 cm. Museum of Art, Rhode Island School of Design

When he was in Rome from 1750 to 1752 Reynolds executed a small group of caricature paintings depicting British visitors to the city. The willing subjects of this

light spirited effort are (l. to r.) John Woodyeare, his tutor the Rev. William Drake, Benjamin Cooke, and Charles Turner. These pictures form an isolated chapter in the career of Reynolds; on his return to England as Northcote reported, he 'held it absolutely necessary to abandon the practise (of caricature); since it must corrupt his taste as a portrait painter, whose duty it becomes to aim at discovering the perfections only of those whom he is to represent.'

10 · THOMAS PATCH (1725–82)

The Golden Asses 1761, pl. I (detail)

Oil on canvas 198.1 × 363.2 cm. Lewis Walpole Library

In a large room in Florence thirty-seven men are conversing, with a punch bowl for their refreshment. The artist is astride a statue of a golden ass. Some of the figures can be identified: from l. to r. are John Apthorp (6), the Duke of Roxburghe (10), to whom Sir Horace Mann (12) hands a letter, Lord Cowper (13), Sir Brook Bridges (17) and Charles Boothby (32). On the walls hang further caricatures showing (l. to r.) an abbé (possibly Anton Maria Biscioni), Sir Henry Mainwaring, Lord Stamford, the Duke of Roxburghe (as a monkey) proposing to Miss Mendes, Lord Doune, and the Rev. Jonathan Lipyeatt. Beneath the golden ass is a quotation from *Dell' Asino d'Oro* by Machiavelli beginning: 'Let nobody approach this rough and obstinate herd if he would not have asinine tricks played upon him; for everyone knows very well that the first thing they do, and one of the best tricks they know how to play, is to let out a couple of kicks and two farts.' According to Lady Mary Wortley Montague, the English in Italy were often referred to as the 'Golden asses' because of their riches and their foolish behaviour. This is the largest and most brilliant of Patch's caricature groups of Englishmen on the Grand Tour, which were eagerly sought after by the subjects, who sometimes drew lots for the right to purchase a painting. Although they might pose for an 'official' portrait by Batoni, it was also a mark of sophistication to be included in such a group. Patch worked in Florence from 1755, and although his paintings are not without a satirical edge, the sitters were privy to the joke.

11 · THOMAS PATCH (1725–82)

Sterne and Death c. 1768–69

Etching (annotated in pen by Horace Walpole) 42.5 × 31 cm (clipped impression) BM 4187 Lewis Walpole Library 768.0.4

Patch had probably seen Laurence Sterne when the author visited Florence briefly in 1765. He died in 1768 and it is possible that this was etched shortly after. The subject is from a passage in *Tristram Shandy*, and various objects allude to Sterne's writings and literary methods; a mincing machine for gutting the contents of books, French

I (CAT. 10 detail)

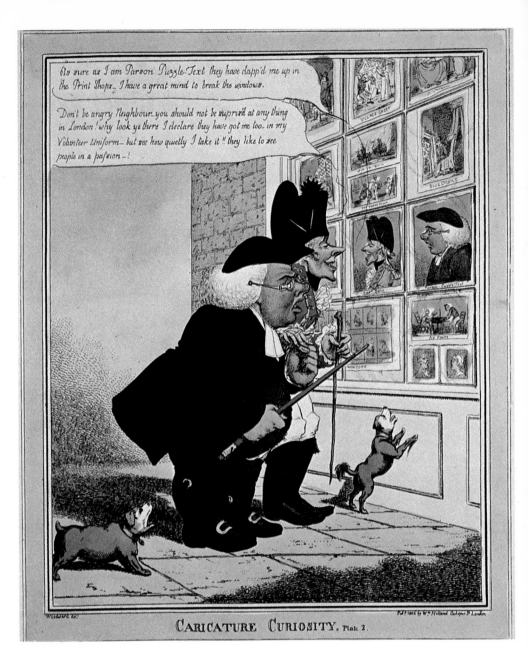

CARICATURE CURIOSITY. Plate 2.

II (CAT. 16)

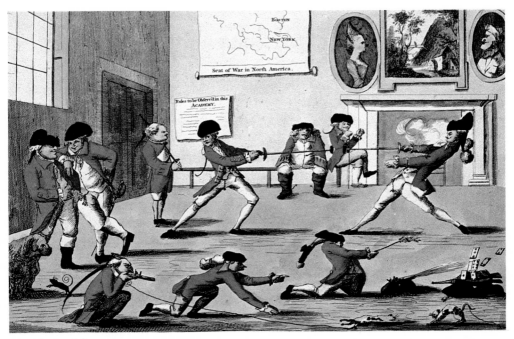

III (CAT. 63)

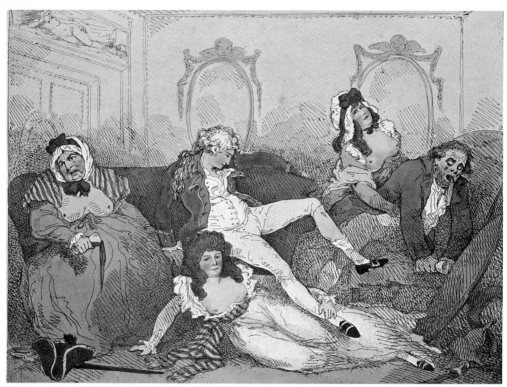

V (CAT. 85)

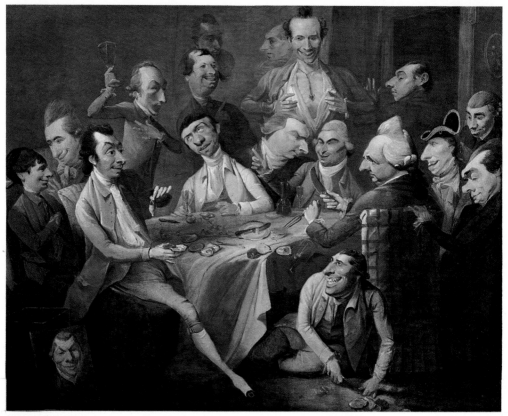

IV (CAT. 79)

postillion's boots (a reference to La Fleur in *A Sentimental Journey*) and a map of fortifications to remind us of Uncle Toby's pre-occupation.

THE PRINTSELLING TRADE

The printshops of London, their windows packed with prints, were a well-known feature of the city, often remarked on by foreign visitors, who also noticed the predominance of caricatures. The shop window was a free entertainment but, with the exception of crude woodcuts, caricatures were not particularly cheap, and were mainly aimed at an educated class. Prints were not issued in regular editions, but according to demand, and the mechanics of copper-plate printing, and in some cases hand-colouring, precluded the rapid production of very large numbers. However, a number of prints are authenticated as best-sellers, including some by Hogarth such as his portrait of John Wilkes, and Benjamin Wilson's *The Repeal, Or the Funeral of Miss Americ-Stamp* (p. 58) which he recorded as selling two thousand impressions in four days. At the other end of the scale are prints which now survive in only a handful of copies, and which may have been printed for private circulation. By the end of the eighteenth century caricature shops were all over London, not only offering prints for sale, but also for hire for the evening in volumes, or in collections, so as to offer a complete caricature history of Britain. By the early 1830s however they had become extinct, replaced by lithographs and wood engravings in the pages of periodicals.

12 · EDWARD TOPHAM (1751–1820),
perhaps engraved by Matthew Darly (*fl.* 1741–80)

The Macaroni Print Shop
Engraving 15.2 × 23.5 cm. Pub. 14 July 1772 (BM 4701)
Library of Congress, Prints and Photographs Division

The exterior of Matthew Darly's shop in the Strand, with caricatures of Macaroni filling most of the window panes. Topham was an adjutant in the Life Guards and an amateur caricaturist. Amateurs were eagerly served by Matthew Darly and his wife Mary, who provided a service etching or engraving their designs. The publishing imprint of 'M. Darly' occurs on many plates, and it is usually impossible to determine which of the two engraved a plate, or whether the work was done by assistants.

13 · MATTHEW DARLY (*fl.* 1741–80)

The Fly Catching Macaroni (Sir Joseph Banks)
Hand-coloured etching 15.4 × 10.8 cm. Pub. 12 July 1772 (BM 4695)
Lewis Walpole Library, Yale University

With his feet on two globes Banks tries to catch an exotic butterfly. A great naturalist, he had travelled to the South Seas with Captain Cook in 1768–71, and had then explored Iceland, collecting many specimens of insects and plants. This print is shown enlarged in *The Macaroni Print Shop*, and is from an extended series of Macaroni prints in the same format.

14 · ANONYMOUS

Ecce Homo pl. 6

Etching and engraving 19.3 × 19 cm. Pub. 1775 (BM 5318)
Library of Congress, Prints and Photographs Division

The window of Matthew Darly's print-shop in the Strand is attacked with lunatic violence by William Austin, a well known drawing master, print seller and caricaturist. His fury was occasioned by the mockery aroused by his scheme to open a 'Museum of Drawings by the best Masters'. A prescription for 'black hellebore' has fluttered to the ground, signed by Dr John Monro, celebrated for his treatment of insanity. This unsigned print is evidently the work of a superior hand, and has sometimes been attributed to Bartolozzi.

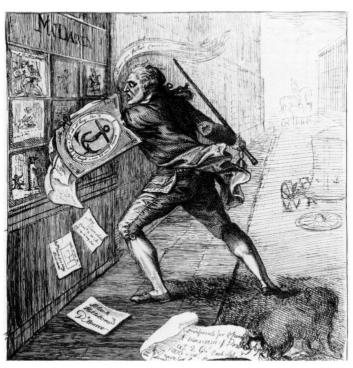

PL 6

15 · ROBERT DIGHTON (c. 1752-1814)

A Real Scene in St. Paul's Churchyard, on a Windy Day c. 1783

Watercolour 32.2 × 24.6 cm. Victoria and Albert Museum D.843-1900, WD.63A

A scene outside the printshop of Carington Bowles, the publisher of a mezzotint after this watercolour, and from many other 'postures' by Dighton. Each pane of the window is filled with a print, the top row being reserved for portraits of divines, including Wesley and Whitefield. Such displays were a very popular feature of London's street life.

16 · GEORGE MURGATROYD WOODWARD (c. 1760-1809)

Caricature Curiosity pl. II

Hand-coloured etching 30.1 × 24.9 cm
Pub. 1806 by Wm. Holland, Cockspur Street, London (not in BM)
Library of Congress, Prints and Photographs Division

Contrasting reactions are displayed by a porcine clergyman and a skinny volunteer officer as they examine caricatures of themselves in what is probably Holland's shop window. Parson Puzzletext is furious, but his companion reacts with good humour.

BOOKS AND DRAWING MANUALS

17 · GIOVANNI DELLA PORTA (c. 1542-97)

De Humana Physiognomia [Naples, 1586], pl. 7

Engravings and letterpress 9.3 × 15.4 cm (plate)
Yale Center for British Art, Paul Mellon Collection

Physiognomy was a science that studied physical appearances to discover individual character. The sixteenth century was rich in publications on physiognomy, but della Porta's was the most important and influential. The link between caricature and physiognomy was often tenuous, although in 1686 Sir Thomas Browne noted: 'When men's faces are drawn with resemblance to some other animals, the Italians call it caricatura.'

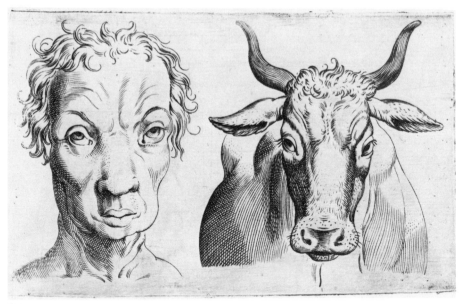

PL 7

18 · MARY DARLY (active 1756–77)

Titlepage and plates 2–4 from *A Book of Caricatures . . . With ye Principles of Designing in that Droll and Pleasing Manner* [London, 1762]

Engraving. Library of Congress, Prints and Photographs Division

Mary Darly was an important caricaturist, printseller and instructor. In the year that this book was published, she was running a shop at Ryder's Court. With her husband Matthew, she was instrumental in creating a market for social satire and in encouraging amateurs to etch their own satirical ideas.

19 · JOHN COLLIER ('Tim Bobbin') (1708–86)
engraved by T. Sanders

Country Bumpkins from *Human Passions Delineated* (Rochdale, 1773), pl. 8 ▷

Engraving 12.7 × 20.4 cm. Yale Center for British Art, Paul Mellon Collection

Netherlandish scenes of rustic genre are invoked by Collier in this grotesque parody of Le Brun's famous treatise on the depiction of human expression. Collier earned his living as a school teacher, but produced many highly original studies of grotesque figures.

20 · FRANCIS GROSE (1731–91)

Plate I (of III) from *Rules of Drawing Caricaturas: With an Essay
on Comic Painting* [London, 1789]

Engraving 21.6 × 13.3 cm. Lewis Walpole Library, Yale University

With regard to this illustration, Grose wrote:

'Ugliness, according to our local idea, may be divided into genteel and vulgar . . .
Convex faces, prominent features, and large aqualine noses, though differing much
from beauty, still give an air of dignity to their owners; whereas concave faces, flat
snub or broken noses, always stamp a meanness and vulgarity. The one seems to have
passed through the limits of beauty, the other never to have arrived at them.'

21 · JOHANN K. LAVATER (1741–1801)

Essays on Physiognomy (English translation, London, 1788–98)

Engravings and letter press. 25.1 × 20.3 cm (plate)
Yale Center for British Art, Paul Mellon Collection

Lavater was the last of the descriptive physiognomists. Poet, philosopher, friend of
Fuseli and Goethe, Lavater actually contributed little that was new on the subject,

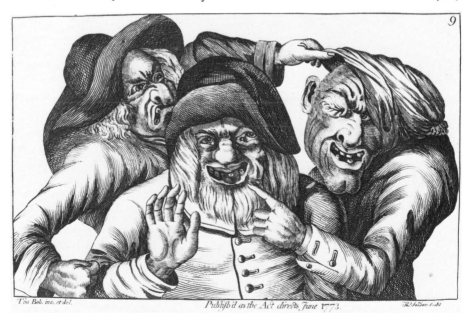

T'os Bob. inv. et del. Publifh'd as the Act directs June 1773. Th. Sanders fculp.

PL 8

although his treatise was read throughout Europe. In the text which accompanies this illustration, a copy of Huber's portraits of Voltaire, he tries to dissociate his 'science' from the practice of caricature:

'... What passes in the mind should be traceable in the face which is the mirror of it. But these traits, these amiable movements are frequently so delicate, and, in faces which have in other respects a strong expression, they are so little perceptible ... that neither the crayon nor the graver is able to catch them; especially in the hand of an artist who deals in caricature.'

22 · JAMES GILLRAY (1765-1815)

Doublures of Characters; – or – striking Resemblances in Physiognomy

Hand-coloured etching 23.5 × 32.7 cm. Pub. 1 November 1798 (BM 9261)
Library of Congress, Prints and Photographs Division

Published in the *Anti-Jacobin Review and Magazine* this attack on the Whig opposition quotes Lavater the Swiss physiognomist: 'If you would know Mens Hearts, look in their Faces'. Numbered from 1 to 7 are Fox, Sheridan, the Duke of Norfolk, Tierney, Sir Francis Burdett, the Earl of Derby and the Duke of Bedford. Their countenances are villainous, and their 'doublures' suggest even further depths of depravity.

23 · THOMAS ROWLANDSON (1756-1827)

Comparative Anatomy Studies c. 1822-25

Pen and ink. The Art Museum, Princeton University

Throughout his career, Rowlandson exploited the comic device of contrasting varied and exaggerated facial types. Toward the end of his life, his physiognomical interests took a more traditional turn, as in this example clearly inspired by della Porta.

24 · E. F. LAMBERT (active 1820s), etched by F.C. Hunt

Rare Specimens of Comparative Craniology:
An Old Maid's Skull Phrenologised c. 1820s, pl. 9

Hand-coloured aquatint 21.1 × 27.4 cm (clipped impression). Unpublished (not in BM)
Library of Congress, Prints and Photographs Division

An ink inscription identifies the phrenologist as Johann Gasper Spurzheim (1776-1832). Phrenology is the study of the skull's shape to determine mental faculties and

character traits. Spurzheim was a student of phrenology's founder, Franz Joseph Gall (1758–1828), with whom he authored a treatise on the subject, translated into English in 1815. Spurzheim lectured in England between 1813–17, and although his science was the subject of great controversy, it enjoyed widespread support.

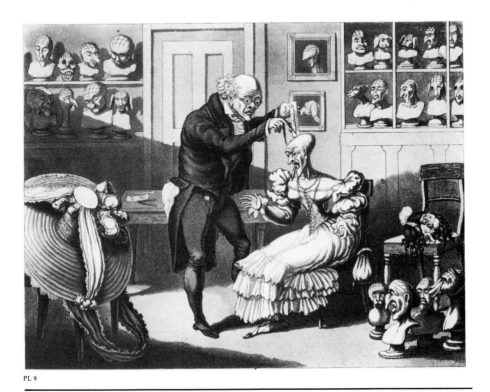

PL 9

25 · J. P. MALCOLM

An Historical Sketch of the Art of Caricaturing London 1813

Yale Center for British Art, Paul Mellon Collection

In this early history of caricature, Californian Indian masks are used to illustrate one of Malcolm's definitions of caricature.

26 · GEORGE CRUIKSHANK (1792–1878)

A Chapter of Noses from *My Sketch Book* London 1834

Hand-coloured etching 19.1 × 27.3 cm (clipped impression). Pub. 1 August 1834
Yale Center for British Art, Paul Mellon Collection

My Sketch Book was the first of the comic almanacks published annually by
Cruikshank until 1853. Beneath serried ranks of bizarre noses, Cruikshank depicts
himself using tongs to pick up by the nose the publisher Kidd. Kidd had been guilty
of publishing illustrations by George's brother Isaac Robert with the simple
signature of Cruikshank, allowing the public to believe that they were by the more
famous artist.

HOGARTH AND HIS CONTEMPORARIES

To his dying day William Hogarth was formulating explanations to clarify the
distinction between caricature, which he saw as a crude and amateurish art, and the
depiction of character, which was the fundamental aim of his work. But the range of
characters that he showed, their variety of physical, moral and social type, formed a
visual dictionary which subsequent caricaturists could plunder and exaggerate. Not
until 1756 was the personal caricature introduced to the political print by George
Townshend. Until then most political satires were emblematic, complicated, and
aimed at a sophisticated audience. Usually uncoloured, they were often carefully
engraved in a manner that did not allow an instant response to the events of the day.
Many are characterized by aggressive opposition to the Government, particularly the
Whig administration of Sir Robert Walpole, and no imagery was too indelicate to be

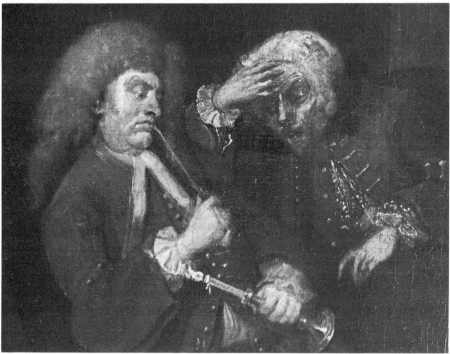

PL. 10

used. Politics was the main subject, but the passing whims of fashion and the social scene were not ignored. Subjects for some of the best prints were artists (including Hogarth), and composers, musicians and writers. Many satirists worked anonymously, but figures such as George Bickham the Younger, Anthony Walker, Paul Sandby and Charles Mosley can be identified as pioneers helping to shape the language of visual humour and invective.

27 · WILLIAM HOGARTH (1697–1764)

A Midnight Modern Conversation c. 1731, pl. 10 (detail)

Oil on canvas 76.2 × 152.9 cm. Yale Center for British Art, Paul Mellon Collection

The painting differs in many details from the engraving published in 1733. Hogarth captioned the print with the warning 'Think not to find one meant Resemblance there / We lash the vices but the Persons spare', but frequent attempts have been made to identify the figures. The purpose of the evening is drunkenness not conversation, and Hogarth drew on an English tradition of representing such scenes in popular prints, in his turn influencing such artists as Rowlandson.

28 · WILLIAM HOGARTH (1697–1764)

A Chorus of Singers

Etching 17.5 × 16.3 cm. Pub. December 1732 (BM 1969)
Lewis Walpole Library, Yale University

The subscription ticket for the engraving of *A Midnight Modern Conversation*. It depicts a cacophonous rehearsal for the unsuccessful oratorio *Judith* written by Hogarth's friend William Huggins and composed by William Defesch.

29 · WILLIAM HOGARTH (1697–1764)
partly engraved by L. G. Scotin (1690– ?)

The Rake's Progress, Plate 2

Etching and engraving 35.6 × 40.8 cm. Pub. June 1735 (BM 2188)
Lewis Walpole Library, Yale University

In eight designs Hogarth chronicled the misadventures of the Rake from his inheritance of wealth to incarceration as a lunatic. At a morning levee his favours are solicited by hangers-on, including a fencing master, a quarter-staff fighter, a dancing

master, a landscape gardener, a hired thug, a French horn player and a jockey. The musician at the harpsichord is a reminder of the struggle for musical supremacy between Handel and his rival, the director Nicola Porpora, who disputed for the services of the singers listed on the score of the imaginary opera, the *Rape of the Sabines*.

30 · WILLIAM HOGARTH (1697–1764)

Characters and Caricaturas pl. 11　　　　　　　　　▷

Etching 25.9 × 20.5 cm. Pub. April 1743. Lewis Walpole Library, Yale University

The subscription ticket for *Marriage a la Mode*. This famous print was intended by Hogarth as a counter blast to the increasing popularity of caricature, which he considered a trifling and amateurish pursuit. At the bottom are copies from Raphael's Cartoons, to illustrate character, and copies from Carracci, Ghezzi and Leonardo (which he took from copies by Hollar and Pond) to illustrate caricature. An assembly of more than a hundred faces is intended to illustrate the infinite variety of character. His success may be doubted, for the main interest resides in the variations of shape possible in a profile. Curiously, women have been excluded.

31 · WILLIAM HOGARTH (1697–1764)
assisted by Charles Mosley (d. 1770?)

The Gate of Calais, or The Roast Beef of Old England

Etching and engraving 38.3 × 45.7 cm. Pub. 6 March 1749 (BM 3050)
Lewis Walpole Library, Yale University

Hogarth visited France in 1748, and on his return from Paris was arrested while sketching the English Gate at Calais. He took his revenge in this classic exercise in English xenophobia, which determined an English image of the lean and beggarly French. Hogarth said of Calais that the 'farcical pomp of war, parade of religion and Bustle with very little business — in short poverty, slavery and Insolence, with an affectation of politeness give you even here the first specimen of the whole country'. On the right is 'a poor highlander fled thither on account of the Rebellion the year before brozing on scanty French fare in sight of a sirloin of beef, a present from England . . . my own figure in the corner with the soldier's hand upon my shoulder is said to be tolerably like'. The original painting is in the Tate Gallery.

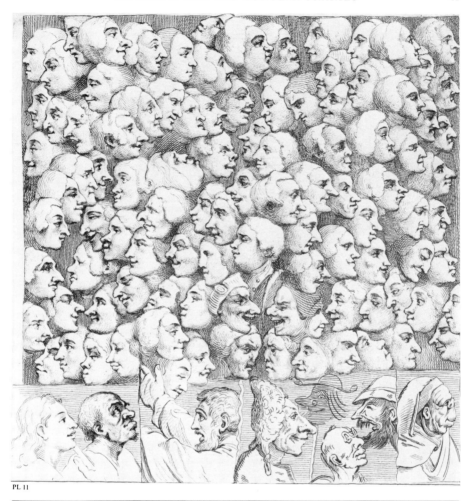

PL. II

32 · WILLIAM HOGARTH (1697–1764)

Chairing the Members Plate 4 from the *Election Series*

Etching and engraving (partially by F. Aveline) 43.5 × 55.7 cm. Pub. January 1758 (BM 3318)
Lewis Walpole Library, Yale University

The series was suggested by the violent contest for Oxfordshire in the election of
1754. Hogarth showed allegiance to neither side nor to historical accuracy; the plump
candidate born in triumph in the chair is in fact the Whig George Bubb Dodington,
who lost his seat at Bridgwater, not Oxfordshire. The original paintings are in the Sir
John Sloane's Museum in London; the extraordinary abundance of human types
they present illustrate the variety of character, but also provided a vocabulary for
succeeding caricaturists.

33 · WILLIAM HOGARTH (1697–1764)

The Times. Plate I

Etching and engraving 24.5 × 30.7 cm. Pub. 7 September 1762 (BM 3970)
Lewis Walpole Library, Yale University

This defence of the unpopular administration of the third Earl of Bute brought a storm of abuse about Hogarth's head. Its substance lies in attempts made by the Government to end the Seven Years War by treaty. The King works a fire-pump aided by loyal English and Scottish subjects, while William Pitt the Elder fans the flames with bellows, an allusion to his attempts to continue the war. In the background the houses of France and Germany burn, and in the foreground King Frederick of Prussia fiddles amongst scenes of poverty. From the top of a house Wilkes and Churchill use clyster pipes to impede the firefighters, aided by Earl Temple beneath. The signboard labelled 'Alive from America' alludes to three Cherokee chiefs who had recently visited London; the money bags allude to the sums raised by their exhibition in public.

34 · WILLIAM HOGARTH (1697–1764)

John Wilkes pl. 12 ▷

Etching 35.6 × 23.1 cm. Pub. 16 May 1763 (BM 4050)
Lewis Walpole Library, Yale University

A popular champion of British liberties, John Wilkes (1727–97) was sent to the Tower after he had attacked the King's speech in the *North Briton*. The same journal had carried Wilkes's attack on Hogarth in 1762, following publication of *The Times Pl. I*, and this best selling print represents Hogarth's revenge. Wilkes is shown at the hearing in Westminster on 6 May when he was discharged. He complained that 'Hogarth sculked behind a screen, in the corner of the Gallery of the Court of Common Pleas; and while Lord Chief Justice Pratt was enforcing the great principles of the Constitution, the painter was employed in caricaturing the prisoner.'

35 · Attributed to PHILIP MERCIER (1689–1760)

The Singing Party c. 1730–36, pl. 13

Oil on canvas 73.1 × 92.1 cm. National Gallery of Art, Washington

Satiric intention is evident in the scene despite its lively realism. The attribution is tentative, but musical themes are frequent in Mercier's work, including a portrait of

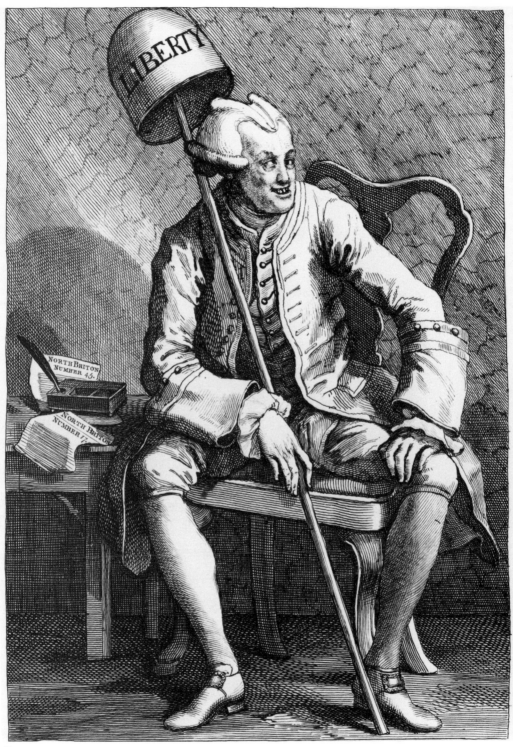

PL. 12

Handel. He was Principal Painter to Frederick, Prince of Wales from 1729 to 1736, and it is not impossible that this picture is connected with the Prince's campaign against Handel and his followers. Of French Huguenot origins, Mercier was born in Berlin and came to England in about 1716, where he did much to introduce French taste in art.

PL 13

36 · JOSEPH GOUPY (*c.* 1680–*c.* 1770)

The true Representation and Character etc c. 1750

Etching and engraving (proof before letters) 46.7 × 31.4 cm (BM 3272)
Pierpont Morgan Library, Peel Collection

Traditionally this elaborate satire was Goupy's revenge on the great composer George Frederick Handel (1685–1759) who, claiming poverty, had invited Goupy to a 'frugal supper'. During this he left the room, supposedly to note down a musical idea, but Goupy found him enjoying a hearty meal in another room. The motive is likely to be more complicated, since Goupy's patron was Frederick, Prince of Wales, who set out to oppose Handel, much admired by George II, whom the Prince hated.

Both Handel's notorious appetite and the loudness of his music are mocked. An ass brays, and cannon fire, clouds of smoke filling the room. This alludes to the use of cannon in the Royal Fireworks Music (1749), when the fireworks had also set fire to a wooden building. In the published state of the print the inscription describes Handel as an 'Harmonious Boar'.

37 · CHARLES MOSLEY (d. *c.* 1770)

The European Race. Heat III. Anno Dom. MDCCXXXIX

Engraving 27.1 × 39.9 cm (clipped impression). Pub. 9 April 1739 (BM 2431)
Lewis Walpole Library, Yale University

This elaborate political allegory sums up the state of European politics from a British point of view, immediately preceding the outbreak of the War of Jenkins' Ear — which eventually became the war of the Austrian Succession. The main British cause of complaint was the harassment by the Spanish of British ships trading with Spanish America, Captain Jenkins complaining in 1738 that the Spanish had searched his ship and cut off his ear in 1731. In this print the past glory of the defeat of the Armada is contrasted with idle British ships boarded by rats. At the umpire's stand in the centre, the Four Continents present gifts to Cardinal Fleury. On the left Trade flees weeping, a British bulldog lies miserably on a carpet looking at the unpopular 'convention signed at Pardo'. A Spaniard crams the convention down the throat of the British representative to Madrid, while Britannia is molested and robbed by a Spaniard and a Frenchman. 'Burbon' and Austria shake hands. The Russian bear and the Turkish elephant fight, the bear speared in the back by a Frenchman, while the German Imperial eagle pounces on the elephant. A lion 'Whelp'd in the Tower' is held by an ape and mounted by a fox, while a Spaniard rubs down a wolf which kicks the French ape. Outstanding use of animal imagery is made in this print, which is from a very popular series.

38 · ANONYMOUS

Idol-Worship or the Way to Preferment pl. 14

Engraving 34.9 × 25.1 cm. Pub. May 1740 (BM 2447)
Pierpont Morgan Library, Peel Collection

Sir Robert Walpole, Prime Minister, and leader of the all-powerful Whigs, blocks the way to St. James's Palace, and to the Treasury, Exchequer, and Admiralty. Only by kissing his buttocks can the aspirant to power and Royal favour proceed. The lines beneath are reminders of Cardinal Wolsey's similar monopoly of power.

39 · Attributed to HUBERT GRAVELOT (1699–1773)

The Devil Upon Two Sticks pl. 15

Etching and engraving. 26.4 × 30.5 cm. Pub. 9 January 1741 (BM 2439)
Library of Congress, Prints and Photographs Division

The corruption of the general election is suggested by the mud over which Sir Robert
Walpole is carried by his supporters. Others attempt to clean themselves, while on
the left a candidate bribes the electors with money he has taken from Britannia's
pocket. His rival, holding the emblem of liberty, is largely ignored.

PL 15

40 · HUBERT GRAVELOT (1699–1773)

And has not Sawney too his Lord and Whore?

Etching and engraving 28.4 × 34.4 cm. Pub. 9 August 1742 (BM 2573)
Library of Congress, Prints and Photographs Division

Alexander Pope was the subject of many idealized portraits, but in this cruel

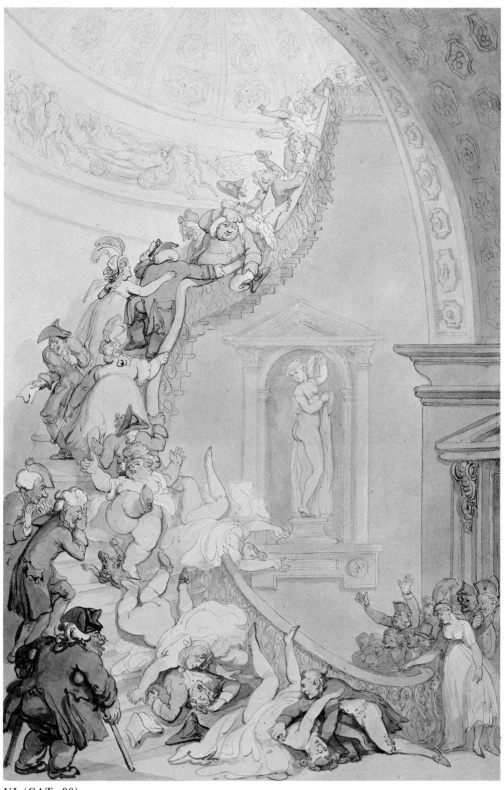

VI (CAT. 90)

A Great Stream from a Petty-Fountain; — or — John Bull swamped in the Flood of new-Taxes; — Cormorants Fishing in the Stream.

VIII (CAT. 109)

VISITING the SICK.

IX (CAT. 110)

VII (CAT. 105)

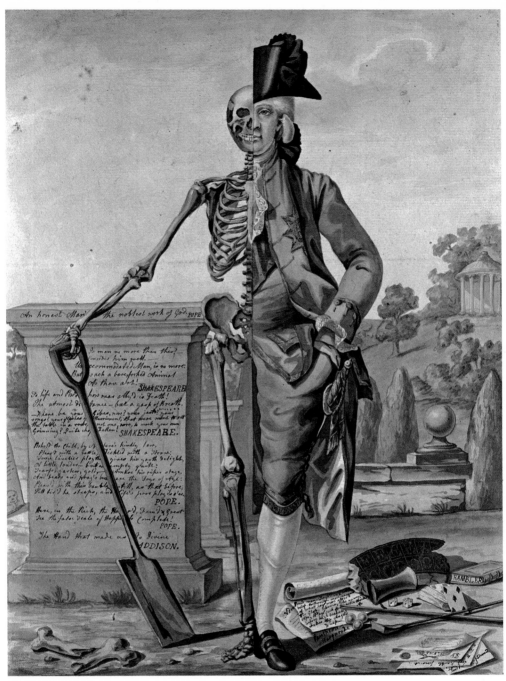

X (CAT. 114A)

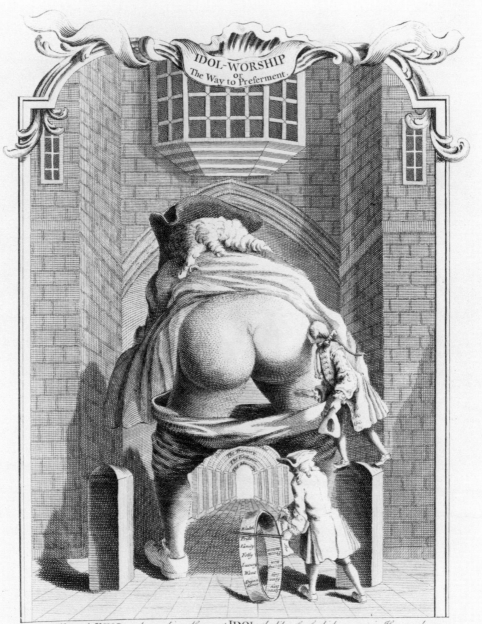

IDOL-WORSHIP
or
The Way to Preferment.

And Henry the **KING** made unto himself a great **IDOL**, the likeness of which was not in Heaven above, nor
in the Earth beneath; and he reared up his Head unto y̆ Clouds, & extended his Arm over all y̆ Land. His Legs also
were as y̆ Posts of a Gate, or as an Arch stretched forth over y̆ Doors of all y̆ Publick Offices in y̆ Land, & whosoever went out,
or whosoever came in, passed beneath, & with Idolatrous Reverence lift up their Eyes, & kissed y̆ Cheeks of y̆ Postern.

Chronicle of the Kings, page 54. Pub 1740.

PL 14

portrayal he is shown being pulled from a prostitute by his bitter enemy Colley
Cibber, the Poet Laureate. Continually mocked by Pope, Cibber took revenge in
public letters in 1742, relating a supposed incident from an earlier period when he
and Pope, with the Earl of Warwick, had repaired to a house of 'carnal Recreation
near the Haymarket; where his Lordship's Frolick propos'd was to slip his little
Homer . . . at a Girl of the Game . . . in which he so far succeeded, that the smirking
damsel, who serv'd us with Tea, happen'd to have Charms sufficient to tempt Mr.
Pope into the next Room with her . . . But I, . . . observing he had staid as long as
without hazard of his Health, he might . . . without Ceremony, threw open the Door
upon him where I found this hasty little Hero like a terrible Tom Tit . . . But such was
my surprise, that I fairly laid hold of his Heels, and actually drew him down safe and
sound from his Danger.' If it was not for its obscenity, the design could almost have
served for one of the Vauxhall Garden decorations, with which it is contemporary.

41 · GEORGE BICKHAM the Younger (c. 1706–71)

Great Britain and Ireland's Yawn pl. 16 ▷

Engraving 30.4 × 24.1 cm. Pub. 11 October 1743 (BM 2607)
Pierpont Morgan Library, Peel Collection.

The yawning face of Sir Robert Walpole suggests the tedium of his long
administration, as do the lines from Pope's *Dunciad* beneath (missing in this
impression):

> 'More he had said, but yawn'd — All Nature nods:
> What Mortal can resist the Yawn of Gods?'

The print was later retitled 'The Late P – m – r – M – n – r', since he had in fact left
office in 1742.

The son of a famous writing master of the same name, Bickham was a productive
and varied engraver and print publisher, noted for his rococo decorative designs as
well as the many satires he engraved and published in the 1740s. He continually
borrowed ideas from other artists; the mouth and eyes are here adapted from an
etching by Ribera.

42 · GEORGE BICKHAM the Younger (c. 1706–71)

This is the Butcher beware of your Sheep

Hand-coloured engraving 32.7 × 20 cm. Pub. c. 1746 (not in BM)
Yale Center for British Art, Paul Mellon Collection L 201.16 (F°)

After the Battle of Culloden in 1746 the defeated highlanders were savagely

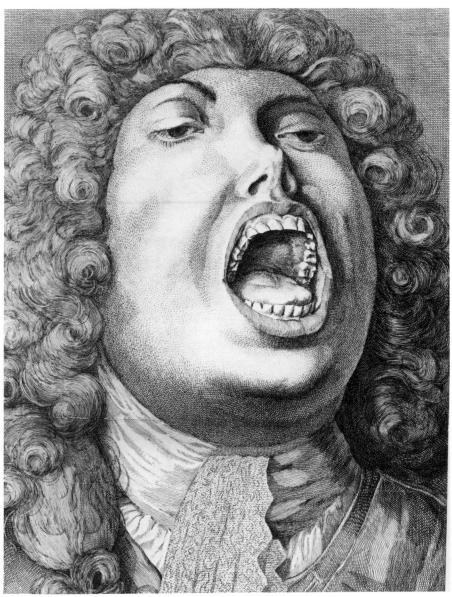

PL 16

suppressed by the British commander, the Duke of Cumberland, who earned the nickname of the 'Butcher'. This print is an adaptation of an etching by the seventeenth-century artist Ribera.

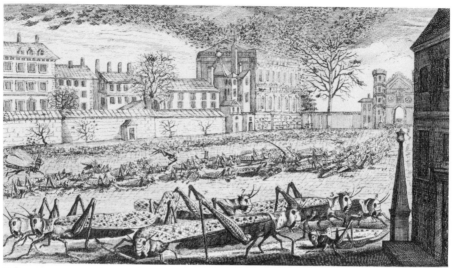

PL. 17

43 · ANONYMOUS

Locusts 1748, pl. 17

Engraving 16.8 × 30.2 cm. (BM 3018). Lewis Walpole Library, Yale University

In the summer of 1748 swarms of locusts did great damage in parts of England, particularly to the leaves of oak trees which looked 'as bare as at Christmas'. Swarming across Whitehall they symbolize the greed of government ministers and such figures as lawyers, priests and excisemen. Most of the numbered locusts in the foreground can be identified. 1, The Duke of Cumberland; 2, Earl Gower, Privy Seal; 3, Duke of Bedford, Secretary of State; 4, Duke of Newcastle; 5, Henry Pelham, Chancellor of the Exchequer; 6, Countess of Yarmouth, the King's mistress; 7, Earl of Sandwich, First Lord of the Admiralty; 8, Possibly Lord Sandys.

44 · GEORGE BICKHAM the Younger (*c.* 1706–71)

The French King's Scheme for an Invasion pl. 18, p. 25

Hand-coloured etching and engraving. 21.9 × 33.6 cm. Pub. 1756 (not in BM)
Pierpont Morgan Library, Peel Collection

Louis XV is represented by a head seen in false perspective so as to resemble the contours of France. The print was published in the first year of the Seven Years War when there were fears of French invasion, here thwarted by the English admirals Hawke and Anson. The crude hand-colouring is unusual for prints of this period.

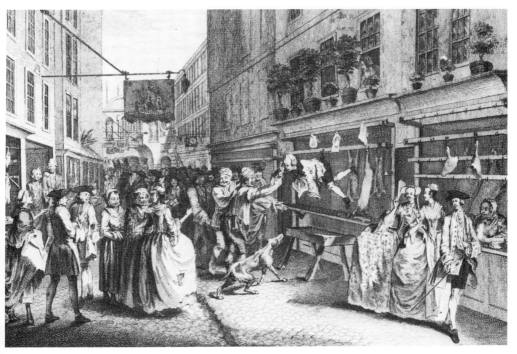

PL 19

THE LADY's DISASTER.——— nil ortum tale. Hor.

PL 20

45 · ANTHONY WALKER (1726–65)

Britannia in Distress 1756

Pen and ink 22.9 × 27 cm. Yale Center for British Art, Paul Mellon Collection

A drawing for an etched satire (BM 3524) showing a dismayed Britannia beneath the collapsing structure of the state. On top of the structure are many frivolous courtiers, loading it with their pensions, and trying to tip a great bulk of them onto Britannia. They are assisted by the unpopular Government of the Duke of Newcastle, Fox, Lord Hardwicke and Anson who pull at ropes labelled 'Minorca lost', 'America Neglected', 'Trade not Protected'. Walker was mainly an illustrator, but a number of his satires can now be identified.

46 · ANTHONY WALKER (1726–65)

The Beaux Disaster c. 1750–54, pl. 19

Etching 18.4 × 29.2 cm (BM 2880). Library of Congress, Prints and Photographs Division

In Butcher's Row, looking towards Temple Bar, a fop has been hung on a hook by butchers and exposed to ridicule. The subject of arrogant exquisites being humiliated by London's working people was to become a favourite subject of the satirist. *The Lady's Disaster* by J. June is a companion print to this.

47 · J. JUNE (*fl.* 1746–70)

The Lady's Disaster pl. 20

Engraving 23.7 × 30.5 cm. Pub. 15 December 1754 (not in BM)
Library of Congress, Prints and Photographs Division

This was no doubt intended as a pair to *The Beaux Disaster*. The inscription records that it was 'Drawn from the fact. Occasion'd by Lady. S carelessly tossing her Hoop to high, in going to shun a littel Chimney sweeper's Boy who fell down just at her feet in an artful surprise, at ye enormous sight'.

48 · LOUIS PHILIPPE BOITARD (*fl.* 1733–63)

The Imports of Great Britain from France

Engraving 19.7 × 33.7 cm. Pub. 7 March 1757 (BM 3653)
Library of Congress, Prints and Photographs Division

A French packet is landing her passengers onto a crowded quay at Billingsgate, from which the White Tower is visible. Boitard, a Frenchman himself, provides a comprehensive view of the passion of the modish English for all things French. Wines are opened and sampled at the right, in the centre an English woman embraces a French dancer, and to their left two Frenchified English children are introduced to their tutor, an abbé who bows gracefully. At the far left emaciated English epicures receive a French cook with great respect. Boitard settled in England in about 1733; he engraved numerous satires specializing in crowded scenes of social humour.

49 · GEORGE TOWNSHEND (1724–1807)

The Recruiting Serjeant or Brittania's Happy Prospect

Etching with woodblock colour printing 20 × 35.5 cm. Pub. April 1757 (BM 3581)
Lewis Walpole Library, Yale University

A satire on the attempts of Henry Fox (represented with a fox's head) to recruit a ministry to replace that of the recently overthrown William Pitt the Elder. In the temple can be seen the Duke of Cumberland on a pedestal. Behind Fox follow Welbore Ellis, vice-treasurer of Ireland, as a drummer, the Earl of Sandwich carrying a cricket bat, Bubb Dodington, and the Earl of Winchelsea. An amateur with a considerable gift for personal caricature expressed in many pen drawings, Townshend with this print established personal caricature as a weapon to be used in political satires. It enjoyed huge success, Walpole noting that 'His genius for likeness in caricature is astonishing'. Townshend's particular hatred was reserved for Cumberland, and the image of him here was described by Walpole as resembling 'a lump of fat crowned with laurel on the altar'. Quarrelsome and vindictive, Townshend (later 1st Marquis) was also a professional soldier, and after the death of Wolfe it was he who took the surrender of the French at Quebec.

50 · PAUL SANDBY (1730–1809)

Puggs GRACES Etched from his ORIGINAL Daubing pl. 21

Etching 17.1 × 22.3 cm. Pub. 1753 (BM 3242)
Library of Congress, Prints and Photographs Division

Hogarth is seated at an easel painting three distorted women. Behind him is a puzzled man holding a copy of Hogarth's *Analysis of Beauty*, published in 1753, and forming the main object of this satire, many of the objects in the room alluding to the book's illustrations. The famous 'line of beauty' is parodied by the distorted gallows on a shelf.

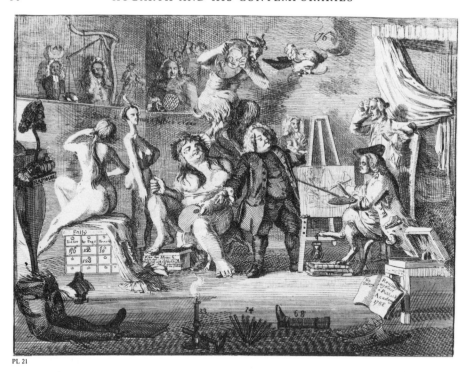

PL. 21

51 · PAUL SANDBY (1730–1809)

The Fire of Faction

Etching 26.6 × 20.3 cm. Pub. September 1762 (BM 3955)
Lewis Walpole Library, Yale University

Hogarth was attacked in a number of prints for his support of Lord Bute in *The Times*. Shown as a devil he stokes the flames with a bellows, while three terrified artists mounted on an engraving tool are driven into the 'jaws of Hell'. The tumbling figure with ass's ears is the writer Henry Howard, and the flames are further stoked by a demon carrying pro-Government journals and prints.

Primarily a landscape watercolourist Sandby was also a brilliant satirist, his attacks on Hogarth having unrivalled vitality of invention.

52 · ANONYMOUS

The vanity of Human Glory: A Design for the Monument of General Wolfe pl. 22

Etching 29.8 × 22.2 cm. Pub. 1760 (BM 3696)
Library of Congress, Prints and Photographs Division

At the base of a monument to General Wolfe a dog urinates on the body of a lion, symbolizing British honour as exemplified by Wolfe who was killed in his victory at the battle of Quebec in 1759. The dog represents Lord George Sackville, much reviled for his cowardly behaviour at the Battle of Minden in the same year, when he refused to give British cavalry the order to charge. However, the unknown artist of this skilful print also slyly mocks Wolfe's distinctive profile, and the pompous conventions of monumental sculpture, at a time when there was eager competition for the commission to make a monument to Wolfe.

THE VANITY OF HUMAN GLORY
A Design for the Monument of GENERAL WOLFE. 1760.

PL. 22

53 · BENJAMIN WILSON (1721–88)

The Repeal, Or, the Funeral of Miss Americ-Stamp

Etching 27.3 × 44.8 cm. Pub. 18 March 1766 (BM 4140)

Lewis Walpole Library, Yale University

This was one of the best selling designs of the eighteenth century, Wilson claiming to
have sold 2000 prints in four days at a shilling apiece, and also reporting that various
copies sold to the number of 16,000. Officially inspired by Edmund Burke, and Gray
Cooper, Secretary to the Treasury, it was published immediately after the repeal of
the Stamp Act by Rockingham's ministry. This unpopular act involved the
imposition of stamp duties on legal documents in America, the money raised to be
used for colonial defence. George Grenville, instigator of the Act, is seen carrying the
coffin of his dead 'child', followed by Lord Bute as chief mourner. Dockside
warehouses have reopened for trade, and the three vessels bear the names of the Act's
opponents; Rockingham, Grafton and Conway. The procession is led by Dr Scott,
author of 'Anti-Sejanus', whose gown is fouled by a dog. The vault is surmounted by
the skulls of traitors, their dates of 1715 and 1745 alluding to Jacobite rebellions with
which the Act's creators are thus associated.

THE SOCIAL SATIRE

Social satires were engraved from an early period, but until the 1770s they were
outnumbered by political subjects, which were often long on meaning but short on
humour. Great stimulus was given to the appreciation of social comedy by the
drawings of amateurs, and by the brief cult of those absurd dandies, the Macaroni,
who were mocked in hundreds of prints. These included mezzotints, a technique
little used in satires hitherto. High fashion was not the only popular subject;
foreigners, especially the French, quacks, lawyers, gullible connoisseurs, actors and
their audience, matrimony, the fat and the thin, were all held up for ridicule. For
many of these prints the stage is London and its streets. Political prints often dated
rapidly, but by its very nature the social satire had a longer life, many prints being
continually re-issued.

54 · JOHN COLLET (*c.* 1725–80), engraved by J. Goldar

The Canonical Beau, or Mars in the Dumps

Engraving. 32.9 × 37.4 cm. Pub. 25 October 1768. Lewis Walpole Library, Yale University

Collet was a semi-professional painter of mild social satires, recalling Hogarth but
lacking his moral force and powers of observation. The painting for this engraving

was exhibited in 1768, and although Collet disavowed any impropriety, contemporary critics interpreted the subject as an indecent depiction of a clergyman in a brothel.

55 · After PIERRE FALCONET (1741–91)

The Female Politicians pl. 23

Etching and engraving. Pub. 8 November 1770 by Ryland & Co. in Cornhill (not in BM)
Pierpont Morgan Library, Peel Collection

Six women battle furiously, portraits on the wall of John Wilkes and the preacher George Whitefield suggesting possible causes of the dispute. The histrionic attitudes of the women also parody serious history painting, a genre sometimes practised by Falconet, a French portrait painter who worked in England from 1765 to 1773.

PL. 23

56 · ANONYMOUS

The Fruit Woman c. 1770

Mezzotint, with Ms.inscription. 34.9 × 25 cm (not in BM)
Library of Congress, Prints and Photographs Division

Four Macaroni, who hog the pavement as they strut past a milliner's shop, are

discomfited by an infuriated old fruit woman who upsets 'Sir Delicate' with her
barrow. Many prints mocked the absurd appearance of the Macaroni in the 1770s,
providing great stimulus to the art of social caricature. The name was given to a set of
young men who had travelled to Italy and founded the Macaroni Club in 1764. It
derives from the Italian dish which they had introduced at Almack's, the gaming
club.

57 · After SAMUEL HIERONYMOUS GRIMM (1733–94)

The Politician pl. 24

Engraving 23.1 × 31.7 cm. Pub. 2 May 1771 (BM 4857)
Lewis Walpole Library, Yale University

Social humour is adapted to political satire as a French hairdresser whispers into the
ear of a dismayed Lord North, the Prime Minister. A cat and dog fight over a map of
the Falkland Islands, the subject of dispute with Spain, over whom the Government
had recently concluded a much criticised treaty. On the floor is a bundle of *Junius's
Letters* in which Lord North had been attacked.

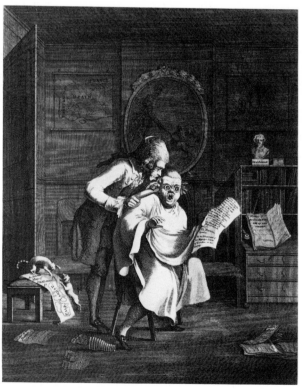

PL 24

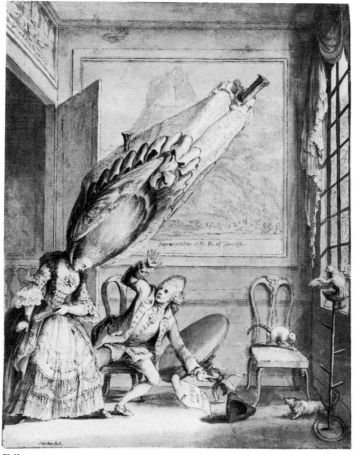

PL. 25

58 · SAMUEL HIERONYMOUS GRIMM (1733-94)

The French Lady in London pl. 25

Pen and ink, with white body colour over pencil 29.2 × 23 cm
Engraved and published 2 April 1771 (BM 4784)
Yale Center for British Art, Paul Mellon Collection

Engraved as a companion to *The English Lady at Paris* this is one of many satires on the mountainous hairstyles fashionable at the time. A contemporary noted that 'Parisian ladies wear high towers with an extraordinary number of flowers, pads and ribbons. The English find such boundless display extremely ill-bred, and if any such lady comes to London, people hiss and throw mud at her.'

Primarily a landscapist, Grimm was born in Switzerland and worked in Paris before coming to London in 1768. His satires are usually of social subjects.

59 · HENRY MORLAND (*c.* 1719–97)
engraved by PHILLIP DAWE (*fl.* 1760–80)

An Italian Connoisseur and Tired Boy pl. 26 ▷

Mezzotint 50 × 35 cm. Pub. 1 November 1773 by R. Sayer (not in BM)
Lewis Walpole Library, Yale University

Morland exhibited the painting several times at the Free Society of Artists, publishing the following description in 1775:

'An Italian Connoisseur and tired boy. The connoisseur is an admirer of no pictures but Italian, therefore his taste is greatly affronted on being shown a Dutch picture; nevertheless his attention is engaged by some effect he sees in the landscape — has forgot the boy, who is tired with holding the picture in a heavy frame, which he is just ready to drop'.

Morland was mainly a painter of genre scenes, but also forged Dutch pictures and employed his son George to do the same.

60 · ANONYMOUS

The Beauties

Mezzotint 35.2 × 25.2 cm
Pub. 20 October 1775 by W. Humphrey, Gerrard Street, Soho (not in BM)
Library of Congress, Prints and Photographs Division

A grotesque encounter between two old and disgusting Macaroni.

61 · ANONYMOUS

Top and Tail pl. 27

Hand-coloured engraving, 32.7 × 20.1 cm (clipped impression)
Pub. 1777 (in Great Castle Street, No. 27 Oxf. Mar.) (not in BM)
New York Public Library (Horace Walpole Collection)

From a pair of bizarre prints satirizing the excesses of female hairstyles, and signed with the facetious pseudonyms of 'Mr. Perwig' and 'Miss Heel'.

62 · JAMES GILLRAY (1756–1815)

Female Curiosity pl. 28

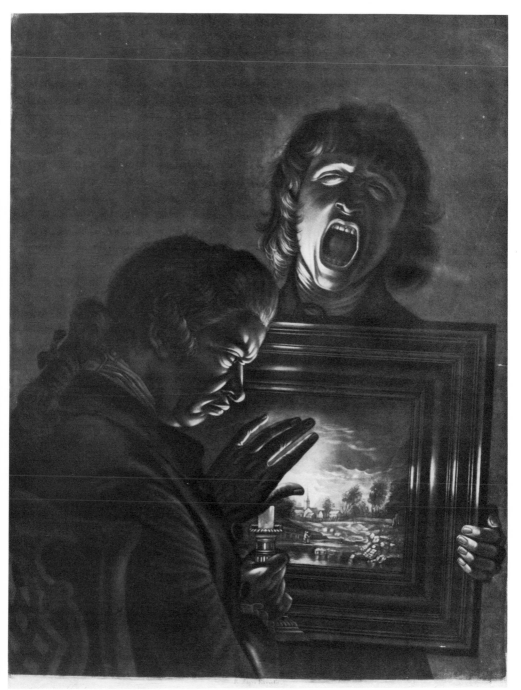

PL 26

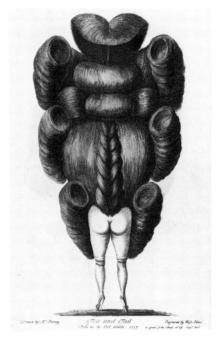

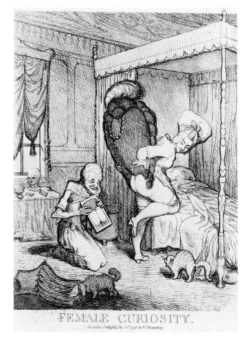

PL. 27 PL. 28

Etching 35.8 × 25.5 cm. Pub. 1 December 1778 by W. Humphrey (not in BM)
Library of Congress, Prints and Photographs Division

Although unsigned this is clearly the work of the young Gillray, who did not begin to
sign his caricatures until much later. The weird eroticism of this example is derived
from the earlier engraving *Top and Tail*.

63 · VERNEY

Qualifying for a Campain pl. III

Hand coloured etching 25.1 × 36.4 cm
Pub. 4 June 1777 (Printed for R. Sayer and J. Bennett) (not in BM)
Library of Congress, Prints and Photographs Division

Frequently derided in caricatures, army officers are shown in farcical training for the
war in America. This was going badly for the British, and four months after this print
was issued Burgoyne was defeated at the Battle of Saratoga. 'Verney' is not otherwise
recorded as an artist, and the coarse execution of the print suggests that it is the name
or pseudonym of an amateur.

64 · after JOHN COLLET (*c.* 1725–80)

An Officer in the Light Infantry, Driven by his Lady to Cox-Heath

Hand-coloured mezzotint 33.1 × 25 cm. Pub. 1778 (BM 4562)
Lewis Walpole Library, Yale University

In 1778 the large military encampment at Coxheath, Kent, became a public attraction and the subject of numerous caricatures. Collet's mildly humorous 'posture' — as these coloured mezzotints were called — depicts a slumbering militia officer being driven to the camp by a dashing female companion.

65 · ANONYMOUS

An English Jack Tar giving Monsieur a Drubbing pl. 29

Mezzotint 34.9 × 25 cm. Pub. 1 May 1779 (not in BM)
Library of Congress, Prints and Photographs Division

The British seaman, in striped trousers and with cudgel or cutlass, was always a popular figure in caricatures. In a typical contrast of national types he thrashes a lean and dandified Frenchman. The print also celebrates the recent acquittal from an unjustified court martial of Admiral Augustus Keppel, and the lettering on the tavern door of 'Keppel's Cordial, Harland's Intire', refers to him and his junior officer.

66 · GEORGE DANCE (1741–1825)

A Man Doing the Splits c. 1780–1800, pl. 30

Pen and ink over pencil 18.6 × 14.4 cm
Yale Center for British Art, Paul Mellon Collection B1975.4.868

Comic routines were popular in the interludes of plays and operas, and this sketch could have been made in London, or perhaps in Italy where the custom originated. Dance had stayed in Rome earlier in his career.

67 · PAUL SANDBY (1730–1809)

Les Caprices De La Goute, Ballet Arthritique pl. 31

Aquatint 37.4 × 45.8 cm. Pub. 1 January 1783 (BM 6322)
Library of Congress, Prints and Photographs Division

Abraham Buzaglo (d. 1788) was a well known quack who professed to cure the gout

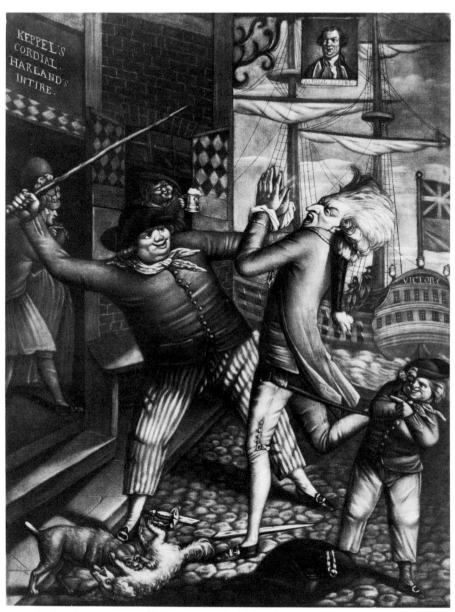

PL 29

by 'muscular exercises'. He is probably the figure in profile at the left, supervising the fitting up of a patient with the wooden 'bootikins' which figured in his treatment. In the foreground, uncomfortably encased in more elaborate equipment, a portly patient attempts the exercises.

PL. 30

LES CAPRICES DE LA GOUTE, BALLET ARTHRITIQUE

THE AMATEURS

Amateurs played a vital role in the evolution of the English caricature, not only in making drawings and prints themselves, but in suggesting ideas to professional artists, and in paying them to improve and engrave their designs. Some of Gillray's best prints were the result of this collaboration. Amateurs did design political prints, but their taste more usually inclined to the social satire, often gentle in humour, and best exemplified by Henry William Bunbury who enjoyed enormous popularity in his day. One reason for the continuing popularity of caricatures in eighteenth-century England was this feeling that the art was accessible to all, with no need for a professional training.

68 · after HENRY WILLIAM BUNBURY (1750–1811)

The Kitchen of a French Post-House

Engraving 41.2 × 43.2 cm. Pub. 1 February 1771 by M. Darly (BM 4764)
Andrew Edmunds Collection

The interior of a kitchen in a French inn, its occupants embodying an English idea of typical French types. An amateur, whose drawings were usually engraved by others,

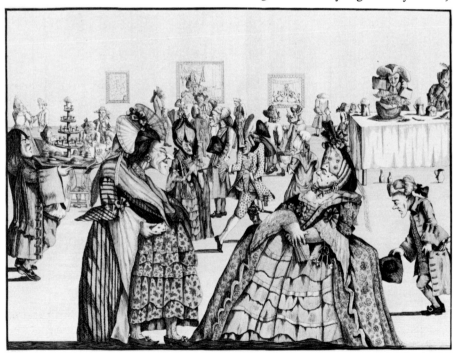

Bunbury's amiable social comedy enjoyed great success in its day. Walpole even noted of this design that it 'perhaps excels the *Gate of Calais* by Hogarth, in whose manner it is composed'.

69 · RICHARD ST. GEORGE MANSERGH (d. 1797)

A City Rout pl. 32

Etching 32.3 × 42 cm. Pub. by M. Darly, 14 March 1772 (not in BM)
Lewis Walpole Library, Yale University

Mansergh was one of the more original amateurs to provide the Darly firm with a fund of comic sketches that they would then professionally engrave and publish. The typical London rout, or party, of the period was characterized by one observer as consisting of 'music, flattery, scraping, bowing, puffing, shamming, back-biting, sneering, drinking tea, etc.'

70 · CHARLES LORAINE SMITH (*fl.* 1762)
etched by JAMES BRETHERTON (*fl. c.* 1770-90)

A Sunday Concert

Etching and aquatint 33.7 × 41.3 cm. Pub. 4 June 1782 (BM 6125)
Library of Congress, Prints and Photographs Division

An amateur depiction of a concert at Dr Burney's in which a number of well known musicians are represented. From left to right the figures may probably be identified as the bass player Cariboldi, Lady Mary Duncan (who was a passionate admirer of Pacchierotti's singing) the oboe player Hayford, and the pianist Ferdinando Bertoni, a Venetian composer. Behind the piano are Pacchierotti, the violinist Salpietro, the oboist J.C. Fischer, the violinist Langani, and the French horn player Pieltain. In the right foreground Dr Burney converses with Miss Wilkes.

71 · HENRY WIGSTEAD (d. 1800)

The History of John Gilpin 1785

Watercolour 40.3 × 63.5 cm. Victoria and Albert Museum

Henry Wigstead was an amateur artist, active from 1784, and a close friend of Rowlandson whose style he imitated. Wigstead illustrates, in the year of its publication, a passage from William Cowper's humorous ballad on the equestrian misadventures of a man embarking on holiday.

'Away went Gilpin, neck or nought;
Away went hat and wig;
He little dreamt when he set out,
Of running such a rig.'

72 · after FRANCIS GROSE (1731–91)

Beauties of Fashion, etc.

Engraving 36.3 × 45.3 cm
Pub. 22 June 1789 by Wm. Holland, Garrick's Richard, No. 50 Oxford Street (not in BM)
Library of Congress, Prints and Photographs Division

Grose was a distinguished antiquarian and amateur draughtsman. This and another
sheet of caricatured heads were issued in the same year that Grose published his *Rules
for Drawing Caricatures: With an Essay on Comic Painting* (London, 1789).

73 · Attributed to FREDERICK GEORGE BYRON (1764–92)

The Knight of the Woeful Countenance Going to Extirpate the National Assembly

Hand-coloured etching 28.9 × 23.6 cm. Pub. 15 November 1790 (BM 7678)
Library of Congress, Prints and Photographs Division

This is one of the earliest attacks on Edmund Burke's *Reflections on the Revolution in
France* (1790). Burke is depicted as a pro-Royalist Don Quixote wearing a miniature
portrait of Marie Antoinette. Astride a papal ass, he issues forth from his publisher's
storefront, a chivalrous anachronism intent on destroying the populist French
National Assembly. As Fanny Burney noted at the time, Burke's 'irritability is so
terrible on that theme (politics), that it gives immediately to his face the expression of
a man who is going to defend himself from murderers.'

FREDERICK GEORGE BYRON (1764–92), etched by Lewis

Breakfast at Breteuil

Etching and aquatint 45.1 × 64.1 cm (clipped impression). Pub. 1 November 1802 (BM 8272)
Lewis Walpole Library, Yale University

This is one of a set of five Byron prints treating the humours of travelling in France in
1790 and including the stock French characters who appear earlier in comparable
scenes by Rowlandson, Bunbury, et al. It is uncertain if the set was published during
Byron's lifetime. Their reissue in November 1802 was undoubtedly prompted by the

Treaty of Amiens which was signed in March of that year and which once again opened the continent, and France, to English travellers.

75 · JOHN NIXON (*c.* 1750–1818)
etched by RICHARD NEWTON (1777–98)

Midnight Revels pl. 33

Aquatint 31.3 × 24.4 cm. Pub. 10 June 1795 (BM 8751)
Library of Congress, Prints and Photographs Division

76 · JOHN NIXON (*c.* 1750–1818)

Lord Amherst, 1799, pl. 34

Pen and ink and wash 20.2 × 13.5 cm. Andrew Edmunds Collection

This caricature was apparently drawn from memory two years after Lord Amherst's death. Jeffrey, Baron Amherst (1711–97) was Commander-in-Chief of the British

PL 33

PL 34

Army in North America (1758–64) and Governor of Virginia (1759–68). His later military career was less distinguished and Horace Walpole frequently described him as an incompetent 'old lady'.

77 · JAMES GILLRAY (1756–1815)
after BROWNLOW NORTH (1778–1829)

Company shocked at a Lady getting up to Ring the Bell

Hand-coloured etching 24.6 × 43.4 cm. Pub. 20 November 1804 (BM 10303)
Library of Congress, Prints and Photographs Division

The five men are presumably suitors of the wealthy woman, eager to be the first to help her. This print is from a set of four etched by Gillray from the designs of the amateur Brownlow North, and purchased by the Prince of Wales for ten shillings and sixpence shortly after publication. A substantial part of the income of caricaturists such as Gillray and Rowlandson came from money received for improving and etching the drawings or ideas of amateurs. These tended to be social satires, but some of Gillray's best known political prints were based on ideas supplied to him by others.

PL 35

78 · COUNTESS OF MORLEY (d. 1857)
after WILLIAM SNEYD (active 1829)

My father, from *Portraits of the Spruggins Family, arranged by Richard Sucklethumkin Spruggins, Esq* (privately printed, 1829), pl. 35

Lithograph 28.6 × 22.2 cm. Yale Center for British Art, Paul Mellon Collection

This collaboration between two amateurs mocks genealogy, aristocratic pretensions, and the private publications of family picture collections, a practice then coming into vogue. The volume contains comic lithographs of fictitious portraits dating back to the sixteenth century.

ROWLANDSON AND GILLRAY

James Gillray and Thomas Rowlandson are the supreme English caricaturists, and also great artists. Gillray was a master of the hand-coloured etching, often epic in conception, and with a sharp political edge. Rowlandson made many prints, but his genius was best expressed in watercolours, especially scenes of social humour. Gillray's career was cut short by insanity, but the productivity of both artists was enormous and touches on almost every issue of the day. The draughtsmanship of both owes something to John Hamilton Mortimer, and Gillray was influenced by the political satires of James Sayers. Few caricaturists have been presented with such a gallery of subjects. Foremost was the rivalry between the Tories, led by William Pitt, who for some time had Gillray in their pay, and the more republican Whigs, headed by Charles James Fox. Their opposition, the French Revolution, the Napoleonic wars, the Royal Family, and the eternal enmity of John Bull and the scheming French, form the vital substance of Gillray's work, which also embraces many scenes of social humour. Both he and Rowlandson set a standard by which later caricaturists must be judged.

79 · JOHN HAMILTON MORTIMER (1740–79)

A Caricature Group ('The Oyster Party') *c.* 1765–68, pl. IV

Oil on Canvas 83.9 × 106.7 cm. Yale Center for British Art, Paul Mellon Collection

Best known as a painter and draughtsman of romantic and historical themes, Mortimer was also a brilliant caricaturist, the style he uses here being of remarkable modernity. The identity of the sitters at this jovial oyster party are debateable, but it is possibly the Howdalian Society founded in 1766. Their possible identities are (l. to r.): Mortimer, John Henderson, John Ireland, Dr Thomas Arne (with raised glass),

Francis Grose (standing and pointing upwards), an unknown figure beneath him, Cipriani (?), in profile, Laurence Sterne (baring his chest), Joseph Wilton the sculptor, using his knife and fork as a hammer and chisel, his wife in front of an unknown man, unknown man at the door, Captain William Baillie in a cocked hat, Charles Churchill behind him and above Oliver Goldsmith. The figure on the floor is possibly James Gandon, the portraits of absent members are possibly (l. to r.) Henry Woodward, Joseph Wright of Derby and P.P. Burdett.

80 · JOHN HAMILTON MORTIMER (1740–79)

Literary Characters Assembled Around a Medallion of Shakespeare c. 1776

Pen and ink 20.4 × 29.8 cm
Yale Center for British Art, Paul Mellon Collection B.1975.4.1346

The identity of the figures portrayed is uncertain, but it is possible that they include the squinting Dr Baretti at far left, Dr Johnson prominent in the right foreground, and Edmund Burke wearing glasses. The figure clutching his forehead may be Mortimer himself, or possibly even Shakespeare, in despair at this scene of excessive adulation. The 'Fellow of Maudlin' (Magdalen College) slumbers in academic oblivion. Mortimer's style of drawing and etching had great influence on the early work of Rowlandson and Gillray.

81 · PHILIPPE JAMES de LOUTHERBOURG (1740–1812)

Revellers on a Coach c. 1785–90

Oil on canvas 42.2 × 61.9 cm. Yale Center for British Art, Paul Mellon Collection

Public transportation in England was often uncomfortable and hazardous to riders and pedestrians. In 1785 and 1790 laws were enacted to prohibit such dangerous overloading of coaches. The French landscape and battle painter de Loutherbourg settled permanently in London in 1771. He occasionally produced comic pictures that have a Rowlandsonian flavour.

82 · THOMAS ROWLANDSON (1756–1827)

E, O, Or the Fashionable Vowels

Etching 18.4 × 25.1 cm. Pub. 28 October 1781 (BM 5928)
Beinecke Rare Book and Manuscript Library, Auchincloss Bequest, Yale University

Although illegal, the E (even), O (odd) roulette table could be found in countless

small gaming houses throughout London in the 1780s. At one shilling a turn the game appealed to the less affluent classes. A House of Commons report in 1782 warned that these houses were open daily, and that servants were enticed to them by cards of direction thrown down on the streets of many neighbourhoods.

83 · THOMAS ROWLANDSON (1756–1827)

Place des Victoires, Paris, c. 1783, pl. 36

Watercolour and pen and ink 23.5 × 53.6 cm
Yale Center for British Art, Paul Mellon Collection. B1981. 17

As a watercolourist, Rowlandson was never as proficient nor as inventive as in his work of the 1780s, and rarely more so than in this early masterpiece. Despite its greater reliance on humorous incident and light-hearted mockery, it is a worthy sequel to Hogarth's scathing indictment of French mores and habits in *Calais Gate*. On the basis of style, the watercolour probably dates to the early 1780s, not long after the artist's trip to France. A large print after the design, etched by Rowlandson, was issued in 1789, almost certainly in response to public interest stirred by recent revolutionary events in Paris.

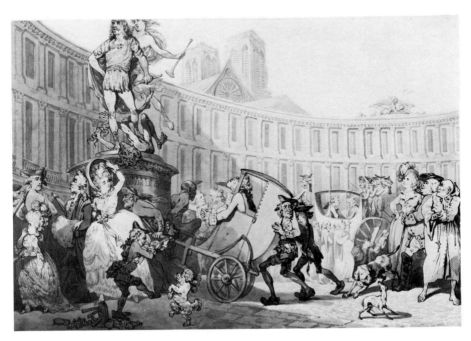

PL 36

84 · THOMAS ROWLANDSON (1756–1827)

The Poll

Hand-coloured etching 22.9 × 33.7 cm. Pub. April 1784 (BM 6526)
Lewis Walpole Library, Yale University

The sensational Westminster Election (1 April–17 May) inspired a flood of visual and verbal propaganda. The caricaturist's task was made easy by the fact that the beautiful Duchess of Devonshire canvassed for Charles James Fox, while his opponent Sir Cecil Wray was supported by the gross Mrs Hobart ('Madam Blubber'). Held down by Hood and Wray (who clutches her backside) Mrs Hobart outweighs the Duchess, although it was eventually Fox who gained more votes. The indelicate imagery is typical of satires on the subject.

85 · THOMAS ROWLANDSON (1756–1827)

The Prodigal Son, c. 1785, pl. V

Hand-coloured etching. Unpublished (not in BM)
Library of Congress, Prints and Photographs Division

This is a variation on an amateur's print published by S.W. Fores on 12 November 1785. The setting is clearly a bordello, and marginal notations identify the bawd as Mrs Windsor, and the central figures as the Prince of Wales and Catherine Barton, alias Kate Bart. The man vomiting is clearly Charles James Fox, to whom the Prince had recently allied himself. Dissolute and extravagant, the Prince was £160,000 in debt by 1785, and his profligate lifestyle continued to embarrass the Royal Family for years. The rarity of this print suggests that it may have been suppressed, the Prince retaining this impression for his own amusement.

86 · THOMAS ROWLANDSON (1756–1827)

Dr. Graham's Earth Bathing Establishment. c. 1785–90, pl. 37

Watercolour and pen and ink 26.4 × 41.6 cm
Yale Center for British Art, Paul Mellon Collection

James Graham (1745–94), 'Emperor of the Quacks', began his medical career in Edinburgh and Philadelphia as an ear-and-throat specialist and pedlar of miraculous nostrums. From the mid 1770s he operated in London a number of health spas, with such features as magnetic thrones, electrical baths, 'celestial' beds for relief from sterility, and immersions. Mocked as a charlatan, he nevertheless believed in his

methods, and his establishments provided first-rate entertainment for the beau-
monde. He publicly demonstrated his belief in earth-bathing by having himself
buried to the chin, his powdered, bewigged head protruding from the slime and
resembling, as one wit observed, a head of cauliflower.

Rowlandson depicts Graham's earth-bathing establishment in Fleet Street, the
man in the blue coat probably representing Graham himself. He advertised this
treatment as a cure for virtually every known ailment from leprosy to gout, and
published several pamphlets on the subject, the last dated 1793 to which he appended
a tract on *How to live for many weeks, months, years without eating anything whatever*
. . . He passed the last years of his life in Edinburgh, periodically under house arrest
for lunacy. However, according to Southey, he would sometimes 'madden himself
with opium, rush into the streets, and strip himself to clothe the first beggar he met'.

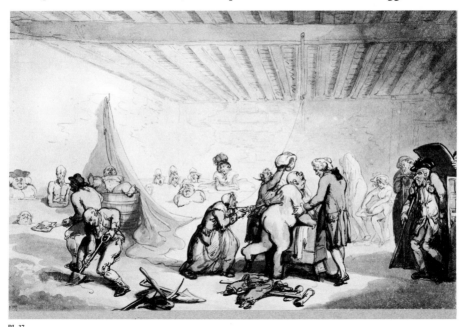

PL 37

87 · SAMUEL COLLINGS (*fl.* 1780–91)

Walking up the High Street
(Study for Plate 4, The Picturesque Beauties of Boswell. 1786
Etched by Rowlandson)

Pen and ink and wash. Art Museum, Princeton University

Collings, an amateur, collaborated on several occasions with Rowlandson. This
drawing is one of twenty recently discovered designs by Collings for a humorous
parody of James Boswell's (1740–95) *Journal of a Tour to the Hebrides with Samuel*

Johnson (1786). Rowlandson etched the plates which were published with captions taken from Boswell's text. The caption for this subject reads: 'Mr. Johnson walked arm in arm up the High Street to my house in James Court. It was a dusky night: I couldn't prevent him being assailed by the evening effluvia of Edinburgh. As we marched along he grumbled in my ear "I smell you in the dark".'

88 · THOMAS ROWLANDSON (1756–1827)

A Worn-Out Debauchee c. 1790–95

Watercolour and pen and ink 30.2 × 20.1 cm
Yale Center for British Art, Paul Mellon Collection B.1975.3.100

The gaunt figure of the old roué has been identified as the fourth Duke of Queensberry (1725–1810), a notorious philanderer known to intimates as 'Old Q' but denounced by Wordsworth as 'Degenerate Douglas'. His female escort is perhaps a prostitute, as suggested by her muff, the word having indelicate connotations in eighteenth-century slang.

89 · THOMAS ROWLANDSON (1756–1827)

A Study of Heads c. 1800

Watercolour and pen and ink. Leger Galleries, London

This study possibly includes a series of self-portraits, the artist imagining what his appearance would be like in old age.

90 · THOMAS ROWLANDSON (1756–1827)

The Exhibition 'Stare-Case' c. 1800, pl. VI

Watercolour and pen and ink 44.7 × 29.8 cm. Etched and published *c.* 1811 (BM11820)
Yale Center for British Art, Paul Mellon Collection. B1981.25.2893

A scene at the annual exhibition of the Royal Academy at Somerset House. The impracticality of parts of Sir William Chambers' architecture, and the jostling of the crowds, here leads to a scene of low comedy of the kind beloved by Rowlandson.

91 · after SAMUEL HIERONYMOUS GRIMM (1733–94)

The Overflowing of the Pitt

Engraving 35.7 × 26.2 cm
Pub. 25 June 1771 (printed for S. Sledge, Printseller in Henrietta Street,
Covent Garden) (not in BM). Lewis Walpole Library, Yale University

A scene of confusion at Drury Lane, anticipating Rowlandson's *Exhibition Stare-Case*. The bill on the wall advertises 'Much Ado About Nothing. Benedick by Mr Garrick'.

PL 38

92 · JOHANN HEINRICH RAMBERG (1763–1840)

The Humours of St. Giles's pl. 38

Etching 28.8 × 40.6 cm. Pub. 20 February 1788 by T. Harmar, Engraver, No. 164
(nearly opposite Bond Street, Piccadilly (not in BM)
Library of Congress, Prints and Photographs Division

The Parish of St. Giles-in-the-fields harboured one of the most notorious London slums. Ramberg's composition is a clever variation on various Hogarth compositions, including *Gin Lane* (1751) which was set in the same neighbourhood. The lodging houses of this district, havens for every order of misfit, were described by Fielding as miserable habitations 'adapted to whoredom' and drunkenness, 'gin being sold in them all at a penny a quart'. He also noted that the stench of the local vagabonds was intolerable.

Ramberg made several satirical prints while a student in London between 1782–88. He later distinguished himself as a caricaturist in his native Hanover.

93 · JOHANN HEINRICH RAMBERG (1763–1840)

Sublime Oratory – A Display of It

Etching 21.4 × 31.4 cm. Pub. 5 March 1788 (BM 7270)
Library of Congress, Prints and Photographs Division

The haughty figure in Oriental costume is Warren Hastings, who had been
impeached in April 1787 for misconduct in office as Governor-General of India
(1775–85). His trial opened on 13 February 1788. Both Burke, here shown as a
mud-slinging Jesuit, and Fox, stooping to gather more ammunition, were furious in
their denunciations. Only Hastings' lawyers stood to gain from the affair, which
lasted seven years, and Ramberg depicts one already filching the defendant's coin
purse.

94 · JAMES BARRY (1741–1806)

The Phoenix or the Resurrection of Freedom

Etching and aquatint 43.1 × 61.3 cm. Pub. December 1776
Yale Center for British Art, Paul Mellon Collection B 1977.14.11067

Liberty is reborn over a temple in North America, while in the foreground a group of
mourners cluster round the tomb of Britannia. They include (l. to r.) Algernon
Sidney, John Milton, Andrew Marvell (all supporters of the Commonwealth), James
Barry, and a seated John Locke. Barry's allegory suggests that civilization and the arts
can no longer flourish in a corrupt England, but only in America amongst a 'new
people of manners simple and untainted'.

Born in Ireland and a close friend of Edmund Burke, Barry is best known for his
massive historical paintings. His liberal, anti-establishment print was etched in
response to the American Declaration of Independence (4 July 1776).

95 · JAMES SAYERS (1748–1825)

Burke on the Sublime and the Beautiful frontispiece

Etching 32.5 × 23.2 cm. Pub. 6 April 1785 (BM 6788)
Library of Congress, Prints and Photographs Division

A scene in the House of Commons displaying the prolixity of Burke's rhetoric, and
the pretensions of his early book, a *Philosophical Enquiry into the Origin of our Ideas of
the Sublime and the Beautiful* (1757). His colleagues receive his words on Indian and
Irish affairs with undisguised boredom. Born in Dublin, Burke (1729–97) was a great

political theorist and rhetorician, and an MP from 1774 to 1794. An early supporter and friend of Fox and the Whigs, he became violently opposed to them after publication of his *Reflections on the Revolution in France* (1790). He was a constant butt of the caricaturists. Sayers was a gifted and productive amateur who etched many caricatures, especially in the 1780s, ridiculing the Whigs and Fox in particular, for which he was rewarded by William Pitt with a sinecure.

PL 39

96 · JAMES GILLRAY (1756–1815)

Monstrous Craws, at a New Coalition Feast pl. 39

Hand-coloured etching and aquatint 36.2 × 47.6 cm. Pub. 29 May 1787
New York Public Library, Walpole Collection

In 1787 much interest was aroused by the exhibition in London of '. . . three wild human beings; each with a Monstrous Craw, being two females and a male, with natural large craws (caused by goitre) under their throat, full of big moving glands which astonishingly play all ways within their craws, according as stimulated by either their eating, speaking, or laughing.' Gillray transfers the craws to Queen Charlotte, the Prince of Wales, and George III who are seen feasting on a dish of gold ('John Bull's Blood') in front of the Treasury. The King and the Prince were usually

at loggerheads, but the former had recently relented sufficiently to support a proposal to pay the Prince's debts out of public funds. The Prince's craw is nearly empty and he looks enviously at Queen Charlotte, who was habitually savagely caricatured by Gillray.

This impression is from a collection of caricatures assembled by Horace Walpole and now in New York Public Library.

97 · JAMES GILLRAY (1756–1815)

A March to the Bank

Etching. 40.6 × 51.1 cm. Pub. 22 August 1787 (BM 7174)
Library of Congress, Prints and Photographs Division

The safety of the Bank of England had been threatened during the Gordon Riots of 1780 and thereafter a regular patrol of the Guards was instituted. The way in which they jostled passers-by led to a number of complaints which had little effect. In a later state of the print Gillray partially covered the exposed limbs of the sprawling fishwoman.

98 · JAMES GILLRAY (1756–1815)

Wierd-Sisters: Ministers of Darkness; Minions of the Moon

Hand-coloured etching and aquatint, (annotated by Horace Walpole) 22.9 × 31.6 cm
Pub. 23 December 1791 (BM 7937). Lewis Walpole Library

The design is an affectionate parody of Fuseli's painting of the witches' scene from *Macbeth*, and Gillray had recourse on other occasions to Fuseli's 'mad taste'. Flanked by ministers Thurlow and Dundas, Pitt looks anxiously at the moon, the lighter side of which represents Queen Charlotte and the darker George III. This alludes to the earlier temporary insanity of the King, and the prospect of a Regency which would have disadvantaged the Tories since, unlike his father, the Prince of Wales favoured Fox and the Whigs.

99 · MATTHEW DARLY (*fl.* 1741–80)

England, Roast Beef and Plumb Pudding. – France. Toad Stools and Garlick

Engraving. Pub. 1 January 1775 (not in BM)
Library of Congress, Prints and Photographs Division

It seems likely that Gillray knew this careful enumeration of satirical clichés about the respective characters of the English and their national enemy, the French. The

framed prints of boxing and fencing reinforce the stereotypes. The bear is more usually an emblem of Russia, but its hearty bulk is here associated with beer drinking and beef eating.

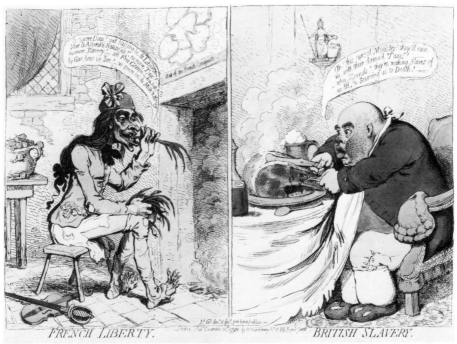

FRENCH LIBERTY. BRITISH SLAVERY.

100 · JAMES GILLRAY (1756–1815)

French Liberty – British Slavery pl. 40

Hand-coloured etching 24.8 × 35 cm. Pub. 21 December 1792 (BM 8145)
Yale Center for British Art, Paul Mellon Collection

The juxtaposition of a starving Frenchman and a plump Englishman feasting on roast beef had been a common place of English satires since Hogarth. The events of the French Revolution inspired Gillray to give it definitive form in a print that was copied in France and Germany. Such images gave foreigners an idea of the English physical type that could lead to disappointment. Louis Simond arrived in London from New York in 1809 and noted that 'Prepossessed with a high opinion of English corpulency, I expected everywhere to see the original of *Jacques Roast-beef*. No such thing; the human race is here rather of mean stature — less so, perhaps than the true Parisian race; but there is really no great difference.'

PL. 41

101 · JAMES GILLRAY (1756–1815)

The Charm of Virtu – or, a cognoscenti discovering the Beauties of an Antique Terminus.
A caricature of Richard Payne Knight. *c.* 1794, pl. 41

Pen and Ink. 31.1 × 23.1 cm (irregular)
New York Public Library, Astor, Lenox and Tilden Foundation

Richard Payne Knight was celebrated as a collector, and as a self-appointed director
of taste. He had also achieved notoriety by his *Discourse on the Worship of Priapus*,

printed for limited circulation in 1786. However, it is likely that the drawing was made in 1794 when Gillray could have read an attack on the *Discourse* in the *British Critic* and seen Lawrence's portrait of Payne Knight in the Royal Academy. Unfortunately he never etched the design which is a typically rough but lively study. A companion sheet is mainly covered with drafts for the title, an aspect of his prints to which he attached great importance. The money bag full of 'old iron' alludes to the origin of the family fortunes; Payne Knight's grandfather was a famous iron-master.

102 · JAMES GILLRAY (1756–1815)

Titianus Redivivus; – or – The Seven-Wise-Men Consulting the New Venetian Oracle, – a scene in ye Academic Grove. No. I (see cover)

Hand-coloured etching 53 × 41.3 cm. Pub. 2 November 1797 (BM 9085)
Lewis Walpole Library, Yale University

Many Royal Academicians had blundered, believing the absurd claims of Mary Provis that she had an old manuscript revealing the 'Venetian secret' — recipes that would enable English artists to equal the colouring of Titian, of whom Gillray shows her daubing a portrait. Beneath are seven Academicians who had stupidly purchased the 'secret', their artistic characteristics deftly parodied in the inscriptions. Prominent is Joseph Farington, an incompetent artist, but a great power in the Royal Academy. On the left a monkey urinates onto the portfolios of artists who had suspected the imposture, the name of the young Turner appearing at the bottom of the list. The President of the Royal Academy, Benjamin West, and the print publishers Macklin and Boydell, who had all been implicated, sneak away unobserved, while the shade of the dead Reynolds emerges from the flagstones.

Although he had studied at the Royal Academy Schools, Gillray had little affection for the place, and was prepared to produce, for an obviously limited market, one of the most brilliant and elaborate satires of the eighteenth century.

103 · JAMES GILLRAY (1756–1815)

Stealing off; – or – Prudent Secesion pl. 42

Hand-coloured etching and aquatint 24.3 × 35.6 cm. Pub. 6 November 1798 (BM 9283)
Pierpont Morgan Library, Peel Collection

The rivalry between Pitt and Charles James Fox, leader of the Whig opposition, was one of the great themes of caricature, given additional zest by the great contrast in their physical appearance. From May 1797 Fox had temporarily exiled himself from the House of Commons, and is seen fleeing while his colleagues literally eat their words after a series of Government triumphs, including Nelson's victory at the Battle

of the Nile. Fox is accompanied by Charles Grey as an 'opposition gray-hound'. Pitt's face is hidden, but he holds up 'O'Connor's list of secret traitors'. O'Connor was an Irish patriot who, in May 1798, was acquitted of treason after Fox and others had testified in his favour. The Opposition's prestige was badly damaged when he shortly after admitted his guilt.

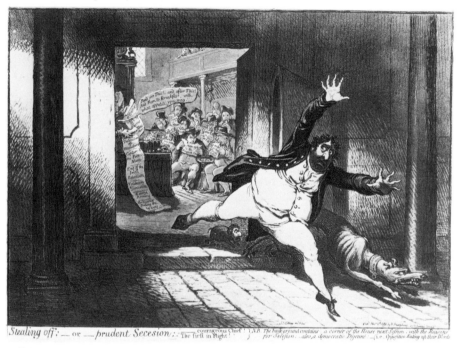

Stealing off: — or — prudent Secesion; — courageous Chief! N.B. The background contains a corner of the House next Sefsion . with the Reasons The first in Flight! for Sécefsion . alos a democratic Dejeune . (i.e. Opposition Eating up their Words

PL 42

104 · JAMES GILLRAY (1756–1815)

Consequences of a Successful French Invasion. 'We fly on the Wings of the Wind to save the Irish Catholics from Persecution.' Scene: The Front of a Popish Chapel 1798

Pen and ink with watercolour 30.8 × 40 cm. Draper Hill Collection

A drawing for the fourth of four prints etched at the request of Sir John Dalrymple, and from his ideas, and serving as warnings of the horrors of French occupation. Dalrymple wrote to Gillray that 'The Irish Roman Catholic one is excellently executed and will do good in Ireland in opening the eyes of these poor people — I will send it there.' A priest is attacked by French soldiers, while another tramps on a Bible crucifix. On the left is a gloating Frenchman from 'la haute Cour de Justice' representing perverted justice. Gillray abandoned the series because of excessive complications and lack of financial reward.

105 · JAMES GILLRAY (1756–1815)

Voltaire Instructing the Infant Jacobinism 1800, pl. VII

Oil sketch on paper 27.3 × 20.3 cm
New York Public Library, Astor, Lenox and Tilden Foundation

In May 1800 Gillray undertook to illustrate a de luxe edition of the *Poetry of the Anti-Jacobin,* but the project foundered since he was unwilling to accept excessive editorial guidance, notably from John Hookham Frere and George Canning. As a result he destroyed those plates he had already etched. The present design was intended to illustrate an *Ode to Jacobinism.*

> ... Voltaire inform'd thy infant mind;
> Well-chosen nurse! his sophist lore
> He bade thee many a year explore!

There are two other oil sketches by Gillray in New York Public Library but this is the most elaborate, and shows genuine feeling for a medium he did not affect.

106 · JAMES GILLRAY (1756–1815)

The Grand Coronation Procession of NAPOLEONE the 1st, Emperor of France, from the Church of Notre-Dame. Decr.2d. 1804

Hand-coloured etching 21.2 × 76 cm. Pub. 1 January 1805 (BM 10362)
Library of Congress, Prints and Photographs Division

Gillray signalled the beginning of 1805 with this elaborate parody of the pomp of Napoleon's Coronation — soon to be officially recorded by J.L. David. The procession is headed by members of the Imperial family, followed by Talleyrand and his wife, and a dejected Pope Pius VII. Napoleon's train is supported by three sycophantic Continental Powers, Spain, Prussia and Holland. Behind them march rows of French generals, who are inconspicuously bound and shackled, and followed by representatives of the secret police carrying sinister attributes.

107 · ANONYMOUS FRENCH ARTIST

Conspiration Découverte. Desespoir des Ennemis de la France à la Découverte de leurs Complots 1804

Hand-coloured etching. Library of Congress, Prints and Photographs Division

In March 1804, Francis Drake, Minister Plenipotentiary to the Elector of Bavaria, was exposed by the French in various intrigues against the French Government. They made much of the scandal, circulating copies of Drake's letters and details of his plots with emigrés, with the result that he was expelled from Munich. The artist has assembled a gallery of the British establishment (borrowing freely from English caricatures) from which significantly the Prince of Wales and the Opposition are separated. Compared to English satires, however, the design and execution is lacklustre. This was one of a large group of French satires purchased by the Prince of Wales from Colnaghi's, a London print dealer.

108 · JAMES GILLRAY (1756–1815)

Uncorking Old Sherry

Hand-coloured etching and aquatint 31.6 × 24.5 cm. Pub. 10 March 1805 (BM 10375)
Library of Congress, Prints and Photographs Division

Gillray's imagery and text were suggested by Pitt's speech in the House of Commons on 6 March, when he responded brilliantly to a long and diffuse speech by Richard Brinsley Sheridan (1751–1816), Whig politician and playwright (notably of *The School for Scandal*), and a frequent butt of Gillray's. Like many politicians before and since, Sheridan enjoyed caricatures of himself and bought six impressions of this famous print.

109 · JAMES GILLRAY (1756–1815)

A Great Stream from a Petty-Fountain; – or – John Bull swamped in the Flood of new – Taxes; – Cormorants Fishing in the Stream pl. VIII

Hand-coloured etching 22.8 × 33.6 cm. Pub. 9 May 1806 (BM 10564)
Library of Congress, Prints and Photographs Division

In 1806 William Pitt died and Lord Grenville and Fox attained power in the so-called 'Ministry of all the Talents', from which Pittites were excluded. After years of protesting against Pitt's taxation schemes they promptly increased income tax in the budget, occasioning the present attack. Taxes are enumerated on the water that gushes from the mouth of Lord Henry Petty; John Bull sinks, losing an oar labelled with Pitt's name. Most prominent of the cormorants are Lord Grenville in the centre, and Fox in front of him.

This impression was bought by the Prince of Wales a few days after publication.

110 · JAMES GILLRAY (1756–1815)

Visiting the Sick pl. IX

Hand-coloured etching and aquatint 25.4 × 35.6 cm. Pub. 28 July 1806 (BM 10589)
Library of Congress, Prints and Photographs Division

Fox died on 13 September of this year, and this cruel print shows him surrounded by comforters including the Prince of Wales (seen from behind), Mrs Fitzherbert (holding a rosary), the Bishop of Meath, and Sheridan who has his hand on the Bishop's shoulder. In the foreground Lord Derby comforts Mrs Fox who had been his mistress.

THE GOLDEN AGE OF ENGLISH CARICATURE

English caricatures were at their most vigorous and original from the 1770s when Gillray began his career, until the second decade of the nineteenth century. During this time printshops multiplied, each with their popular window display, and the supreme inventions of Gillray and Rowlandson were augmented by a host of minor artists, professional and amateur. Hand-coloured etchings were now the standard product, rapidly published, available for sale as single prints, or even to be hired out for the evening in volumes. However vitriolic their assaults on public figures, they were virtually immune from prosecution, and many of the great targets such as Charles James Fox and George IV were also eager collectors of caricatures. The great themes of war and revolution predominate, but no scandal was too trivial to be neglected by caricaturists, and their imagery and drawing was free from the restraints of academic training. Many of the ideas pioneered here are still being used by modern cartoonists.

111 · WILLIAM AUSTIN (1721–1820)

The Merits and Defects of the Dead by their Ingenious Secretary Lord L N

Hand-coloured etching 29.5 × 38 cm. Pub. 1 May 1773 (BM 5122)
Lewis Walpole Library, Yale University

George Lyttelton, 1st Baron Lyttelton (1709–73) enjoyed a respectable career as a politician and a considerable reputation as an author. Although a benevolent character, he possessed a lanky, awkward carriage and a disagreeable voice. Here he confronts an equally repugnant gravedigger in a scene satirizing his own literary fantasy *Dialogues of the Dead* (London, 1760). The print anticipated Lyttelton's death by only two months.

112 · THOMAS COLLEY (active 1780–83)

De Estaing at Spa or the French Admiral in all his Glory c. 1780, pl. 43

Engraving 25.1 × 35.1 cm (not in BM)
Library of Congress, Prints and Photographs Division

Charles Hector, Comte D'Estaing (1729–94), Vice-Admiral of the French fleet, was sent to aid the Americans against the Royal Navy in 1778. This caricature was probably made shortly after his return to Paris in 1779, his expedition having ended in failure. He later had the misfortune to command the National Guard at Versailles in 1789, an offence for which he was guillotined. He is shown eating frogs, which were and are a traditional English symbol for the French, although in earlier satires the image was reserved for the Dutch.

PL 43

113 · WILLIAM DENT (active 1783–93)

The Political Cerberus

Engraving 22.2 × 33.7 cm. Pub. 3 March 1784 by J. Ridgway, Piccadilly (BM 6481)
Library of Congress, Prints and Photographs Division

In one of the profusion of satires on the unpopular Coalition that gave Fox a majority in the House of Commons, Dent shows Lord North, Fox (in the centre) and Burke, as Cerberus, the three-headed dog of Greek mythology, jealously guarding the Treasury. Attached to the beast's collar are the Prince of Wales feathers, and on its tail is inscribed 'Euphorbium, alias stinking popularity', an allusion to a recent incident when at a political meeting someone had thrown a bag of euphorbium in Fox's face. This print was re-issued by H. Humphrey.

114 · ROBERT DIGHTON (*c. 1752-1814*)

Death and Life Contrasted, or An Essay on Man pl. X
Life and Death Contrasted, or An Essay on Woman pl. XI

Watercolours (a pair) 32.5 × 25.1 cm, 33 × 25.2 cm. Pub. *c.* 1784 (BM 3792-93)
Andrew Edmunds Collection

115 · ROBERT DIGHTON (*c. 1752-1814*)

A Fashionable Lady in Dress and Undress

Hand-coloured etching 27 × 19.7 cm. Library of Congress, Prints and Photographs Division

116 · ANONYMOUS

The Tooth Drawer c. 1790

Watercolour and pen and ink 26.7 × 36.9 cm
Yale Center for British Art, Paul Mellon Collection B1977.14.4276

The ordeal of dentistry has been a popular theme for comic drawings from an early period.

117 · JOHN BOYNE (*c. 1750-1810*), engraved by E. SCOTT (*c. 1746-c. 1810*)

The Smoaking Club

Stipple engraving 34.3 × 44.8 cm. Pub. 10 January 1792 (BM 8220)
Library of Congress, Prints and Photographs Division

118 · JOHN KAY (1742–1826)

Convention of Asses or the Spirit of Democracy

Etching 11.6 × 8.9 cm. Pub. (?) December 1792 (BM 8151)
Beinecke Rare Book and Manuscript Library, Yale University

This crude etching by the provincial caricaturist John Kay was intended to ridicule
the Convention of delegates from the Societies of the Friends of the People
Throughout Scotland, which convened in Edinburgh on 11 December 1792. With
the French National Assembly as a model and with the encouragement of native
radicals such as Tom Paine, reform societies like the 'Friends of the People' were
becoming popular. The Scottish convention and rumours of insurrection particularly
alarmed the government in London.

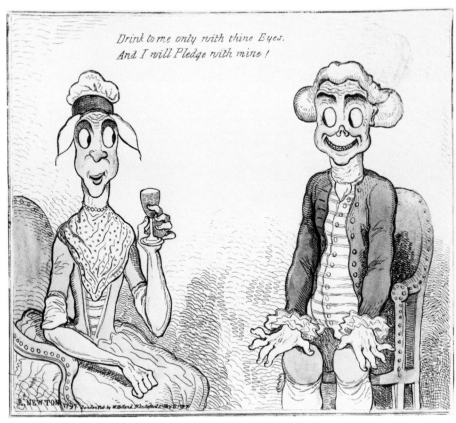

119 · RICHARD NEWTON (1777-98)

A Scots Concert! pl. XII

Hand-coloured etching and aquatint 39.1 × 52.2 cm
Pub. 4 February 1796 by William Holland (not in BM)
Yale Center for British Art, Paul Mellon Collection. B1981.25.1481

In the eighteenth century the caricaturist was sure of a ready audience for gibes at the Scots, not yet romanticized by writers and artists of a later period. They were usually shown as lousy and noisome, absurdly clad, comical and sometimes threatening. The prejudice was age-old; Newton's print could serve as an illustration to John Skelton's early sixteenth-century verse:

O Ye wretched Scots
Ye puant pisspots
It shall be your lots
To be knit up with knots
Of halters and ropes
About your traitors' throats . . .
And ever to remain,
In wretched beggary,
And maungy misery,
In lousy loathsomeness
And scabbed scorfiness . . .

120 · RICHARD NEWTON (1777-98)

◁

Drink to me only with thine Eyes pl. 44

Hand-coloured etching 22 × 25 cm
Pub. 8 May 1797 by William Holland, No. 50 Oxford Street (not in BM)
Library of Congress, Prints and Photographs Division

Despite his premature death aged 21, Newton left behind a large body of boldly drawn etchings which tap a coarse, but rich vein of humour. His figures are often characterized by goggle-eyes. He was evidently a favourite of the Prince of Wales, for his work is strongly represented in the Library of Congress collection.

121 · WILLIAM O'KEEFE (active 1794-1807)

A Vision, Vide – The Monster of Slaughter, the Distress of Mankind pl. 45, p. 1

Hand-coloured etching 24.9 × 35.2 cm. Pub. 26 March 1796 by I. Potts (not in BM)
Yale Center for British Art, Paul Mellon Collection. B1981.25.1512

O'Keefe uses the apocalyptic imagery of the Book of Revelation, showing William Pitt as the Great Red Dragon hovering above a 'Deluge of Blood', while Fox peers through a gap in the clouds. Pitt had recently failed to conclude a peace treaty with France, and this was not the first print by this little known artist to show Pitt as a bloodthirsty warmonger. His imagery was probably also suggested by the apocalyptic prophecies of Richard Brothers (1757–1824).

122 · RICHARD NEWTON (1777–98)

A Political Hypochondriac

Hand-coloured aquatint 26.1 × 39.3 cm. Pub. 18 April 1798 (BM 9195)
Library of Congress, Prints and Photographs Division

An ailing, and perhaps inebriated Pitt, is attended to by Viscount Melville. The print attacks the Prime Minister's foreign policy and the new taxes on housing, carriages, dogs and hair powder. Throughout his life Pitt was said to have imbibed port freely on the advice of his physician.

123 · ISAAC CRUIKSHANK (1762–1811)

The Political Locust pl. XIII

Hand-coloured etching 24.8 × 36 cm. Pub. 14 August 1795 (BM 8672)
Library of Congress, Prints and Photographs Division

High taxes, military setbacks, food shortages, and an influx of destitute French clergy triggered, during the summer of 1795, a series of satires of Pitt as a devouring insect nibbling at the remains of 'poor old England'.

124 · ISAAC CRUIKSHANK (1762–1811)

The French Bugabo Frightening the Royal Commanders

Hand-coloured etching 24.5 × 48.9 cm. Pub. 14 April 1797 (BM 9005)
Library of Congress, Prints and Photographs Division

In April 1796, the Directory gave Napoleon command of the French army in Italy. He rapidly defeated the superior forces of Austria and Sardinia, and then 'liberated' Italy, showing little respect for the Papacy. Austria sued for peace in the winter of 1797. Cruikshank's depiction of Napoleon is not a personal caricature, but shows him as a traditional national type. At the time he was not sufficiently well known in England to merit personal attention.

125 · GEORGE MURGATROYD WOODWARD (*c*. 1760–1809)
etched by Isaac Cruikshank (1762–1811)

Johnny in a Flatting Mill pl. 46

Hand-coloured etching 20.2 × 44.5 cm. Pub. 25 May 1796 (BM 8808)
Yale Center for British Art, Paul Mellon Collection. B1981.25.1917

In 1796 the Treasury was thin, and national debt rising, fuelled by inflationary issues of paper money and huge military subsidies to allies. The usually rotund John Bull is here stretched flat by Pitt and Viscount Melville, Treasurer of the Navy, between rollers of excessive government spending and taxation.

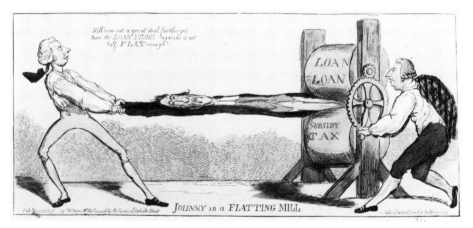

PL 46

126 · ANONYMOUS

Johnny Bull's Defiance to Bonaparte!

Hand-coloured etching 34.9 × 24.7 cm
Pub. December 1803 by Wm. Holland No. 11 Cockspur Street, Pall Mall (not in BM)
Library of Congress, Prints and Photographs Division

John Bull aggressively invites Napoleon to battle in this crude print, sub-titled 'A Parody on Shakespeare's Richard III', and published when the threat of French invasion was very real. John Bull's ugliness and crass vulgarity was often associated in caricatures with virtue and honesty, in contrast to the vulpine guile of the French.

127 · JOHN CAWSE (1779–1862)

An Ever Green pl. XIV

Hand-coloured etching 51.6 × 11.1 cm. Pub. 3 April 1806 (BM 10548)
Library of Congress, Prints and Photographs Division

Even posthumously William Pitt's lean figure and memorable profile remained tempting to caricaturists, unwilling to abandon the subject.

128 · GEORGE MURGATROYD WOODWARD (*c.* 1760–1809)
etched by I. Cruikshank

An Irish Epitaph

Hand-coloured etching 21.2 × 32 cm. Pub. 1807 (BM 10914)
Library of Congress, Prints and Photographs Division

Typical of the crudely coloured prints issued by Thomas Tegg, this is a characteristic English joke at the expense of the supposed illogicality of the Irish.

129 · GEORGE MURGATROYD WOODWARD (*c.* 1760–1809)

Titlepage to *The Caricature Magazine or Hudibrastic Mirror*, Vol. I, 1807

Hand-coloured etching (BM 10889) 23.5 × 33.3 cm
Library of Congress, Prints and Photographs Division

The *Caricature Magazine* was founded by Thomas Tegg, a publisher specializing in the sale of cheap caricatures. Although designed by good artists such as Rowlandson and Woodward, Tegg's prints were crudely produced and coloured. Aiming at the widest audience he gingerly avoided political subjects. This 'magazine' consisted of five volumes of nearly 500 prints published annually between 1807 and 1812. A newspaper advertisement for Volume I indicated one aspect of Tegg's ambitions:

'Noblemen, Gentlemen, etc. wishing to ornament their Billiard or other Rooms, with Caricatures may be supplied 100 percent cheaper at Tegg's Caricature Warehouse. Merchants and Captains of Ships supplied Wholesale for Exportation.'

XI (CAT. 114B)

XII (CAT. 119)

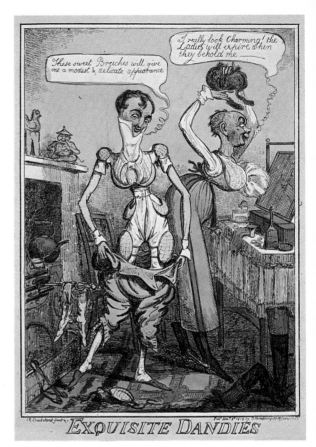

XV (CAT. 135)

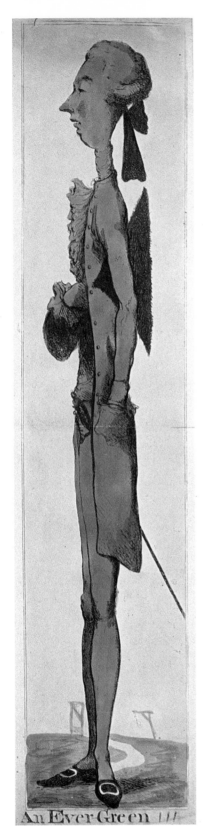

XIV (CAT. 127)

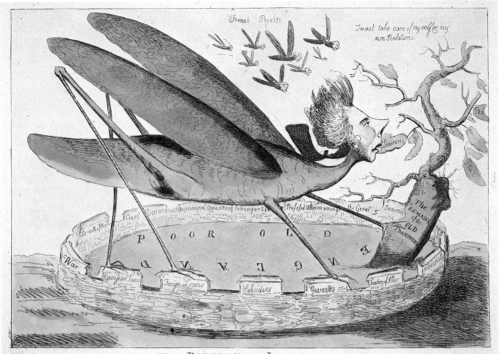

The POLITICAL LOCUST

XIII (CAT. 123) XVI (CAT. 136)

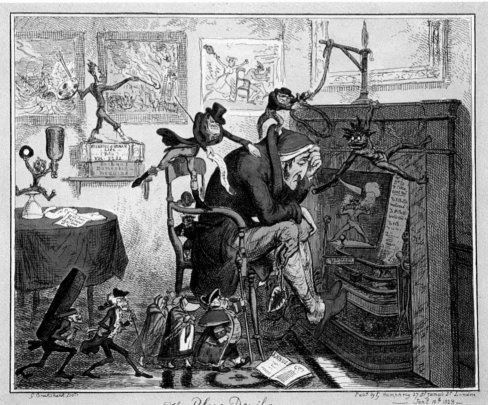

The Blue Devils —

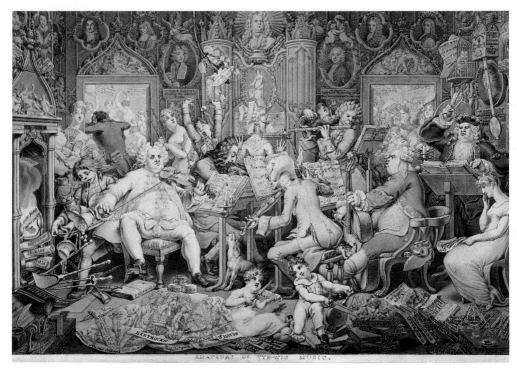

AMATEURS OF TYE-WIG MUSIC.

XVII (CAT. 144)

REFLECTIONS ON MATRIMONY.

THE HONEY MOON.

AND AFTERWARDS.

XVIII (CAT. 147)

REGENCY, RADICALS AND REFORM

In 1812 the Prince of Wales became Regent, ruling in place of George III who had become hopelessly insane, but was to live until 1820. By 1830 when William IV came to the throne, the tradition of the hand-coloured etching, often coarse and outspoken was beginning to fall from favour, and by 1840 it was extinct. But the climactic years of the old style are full of vitality, George Cruikshank inheriting the mantle of Gillray, and artists such as William Heath and C.J. Grant producing many original prints. Colourful subjects were provided by Napoleon's retreat from Russia, the cult of the dandies, and the moral failings of the Prince Regent. Catholic emancipation and the Irish question, the violent agitation for Parliamentary Reform, were subjects for which caricaturists were prepared to take up the cudgels, sometimes for both sides at the same time. The Reform Bill of 1832 was the last great issue to be colourfully debated in the print-shop windows. Thackeray lamented their passing, and the replacement of the old vulgarity by the more gentlemanlike humour and satire of the Victorians.

130 · GEORGE CRUIKSHANK (1792–1878)

Boney Hatching a Bulletin or Snug Winter Quarters pl. 47

Hand-coloured etching 24 × 34.5 cm. Pub. December 1812 (BM 11920)
Library of Congress, Prints and Photographs Division

The disastrous situation of the French army as it retreated from Moscow was concealed by Napoleon in a series of deceptive bulletins. Cruikshank satirizes the 27th Bulletin of 27 October: 'It is beautiful weather, the roads are excellent . . . this weather will last 8 days longer, and at that period we shall have arrived in our new position.'

131 · GEORGE CRUIKSHANK (1792–1878)

Buonaparte! Ambition and Death!!

Hand-coloured etching 20.6 × 50.8 cm. Pub. 1 January 1814 (BM 12171)
Library of Congress, Prints and Photographs Division

Cruikshank has adopted an unusual triptych format for one of his less familiar Napoleonic essays. The left panel treats Napoleon's ruthless rise to power; the right panel predicts his ultimate demise. The inspiration for the print was Napoleon's resounding defeat at Leipzig (16–20 October 1813), the subject of the central section, in which Death commences to mark the Emperor's time.

Boney Hatching a Bulletin or Snug Winter Quarters!!!

PL 47

132 · GEORGE CRUIKSHANK (1792–1878)

Inconveniences of a Crowded Drawing Room

Hand-coloured etching 25 × 35 cm. Pub. 6 May 1818 (BM 13046)
Lewis Walpole Library, Yale University

A chaotic scene at a formal reception given by Queen Charlotte at Buckingham
House (now Palace).

133 · GEORGE CRUIKSHANK (1792–1878)

The Radical's Arms pl. 48

Hand-coloured etching 34.8 × 23.6 cm. Pub. 13 November 1819 (BM 13275)
Library of Congress, Prints and Photographs Division

1819 was a tense year of economic difficulties, unemployment, and mounting cries
for reform. Popular protests and mass meetings aroused fears of impending
revolution. Cruikshank was possibly working from an amateur's idea in this

association of radical ideals with savage revolution, with a guillotine prominently displayed. Parodies of the conventions of the coat of arms had long been a favourite with caricaturists.

134 · GEORGE CRUIKSHANK (1792–1878)

Monstrosities of 1822

Hand-coloured etching 25.2 × 35.6 cm. Pub. 19 October 1822 (BM 14438)
Library of Congress, Prints and Photographs Division

Between 1816 and 1825 Cruikshank produced nine prints satirizing the annual 'monstrosities' of fashion. The promenade of the fashionable in Hyde Park is here set against a background of the Achilles statue and the houses of Park Lane.

135 · ISAAC ROBERT CRUIKSHANK (1786–1856)

Exquisite Dandies pl. XV

Hand-coloured etching 35.2 × 25 cm
Pub. 8 December 1818 by G. Humphrey, 27 St James's Street (not in BM)
Library of Congress, Prints and Photographs Division

The absurd costumes of the dandies of the Regency provided caricaturists with targets unrivalled since the Macaroni of the 1770s, the best prints being those by George Cruikshank and his elder brother Isaac Robert, who sometimes collaborated. The ideals of Beau Brummell, the greatest dandy, were based on simplicity, cleanliness, and witty style, but his imitators were more often distinguished by vanity and vulgarity.

136 · GEORGE CRUIKSHANK (1792–1878)

The Blue Devils pl. XVI

Hand-coloured etching 21 × 25.6 cm. Pub. 10 January 1823 (BM 14598)
Library of Congress, Prints and Photographs Division

To suffer from 'blue devils' was to be low spirited, or in modern parlance to have the 'blues'. They here incite the miserable debtor to suicide, while beneath him strut Death and a coffin-bearer and three pregnant women escorted by a beadle.

137 · GEORGE CRUIKSHANK (1792–1878)

Constantine I 1826

Pencil and watercolour 26.5 × 28.8 cm. Victoria and Albert Museum 966 A

The Grand Duke Constantine Pavlovitch (1779–1831) renounced the Russian succession in 1822, and refused to be named Tsar in December 1825. He subsequently became a highly autocratic Governor of Poland. Cruikshank deftly explores variations of profile in this study for an etching published on 12 January 1826.

138 · CHARLES WILLIAMS (fl. 1797–1830)

The Comet of 1811

Aquatint 21.6 × 27.9 cm. Pub. January 1811 (BM 11705)
Library of Congress, Prints and Photographs Division

In December 1910, George III's insanity prompted urgent consideration of the Regency question. During the first Regency crisis of 1789, Sayers had issued a satire of the Prince of Wales as a comet trailing the heads of his political supporters. Williams has plagiarized this idea, making only the necessary substitutions of personnel in the tail. This new cast includes Moira, Sheridan, Lord Derby and the three Grenvilles, who were already active in forming a Cabinet.

139 · Attributed to WILLIAM HEATH (*c.* 1795–1840)

The Royal Milling Match

Hand-coloured etching 22.5 × 34 cm. Pub. December 1811 (BM 11746)
Library of Congress, Prints and Photographs Division

The Prince Regent had injured his leg while teaching Princess Charlotte to dance a Highland fling, but caricaturists delighted in connecting his injury with a supposed quarrel with Lord Yarmouth over the attentions the Prince was paying to Lady Yarmouth. She looks from behind a screen which is covered with caricatures, illustrating a popular use of the prints.

This print is one of a number in the Library of Congress inscribed 'suppressed', meaning that the Prince had paid to have the print withdrawn, and the fact has been recorded on his personal copy. This is an early example; the majority of such prints are from 1819 and 1820.

PL 49

140 · WILLIAM ELMES (*fl.* 1811–1820)

The Yankey Torpedo pl. 49

Hand-coloured etching, 27 × 40.4 cm. Pub. 1 November 1813 (BM 12090)
Library of Congress, Prints and Photographs Division

The British naval blockade of New York during the War of 1812 required drastic American countermeasures. One such invention was Robert Fulton's (1765–1815) submersible craft that could be detonated beneath the hull of a ship. Its success was very limited, and Jack Tar reacts with contempt to Yankee blustering.

141 · RICHARD DIGHTON (1795–1880)

A Motley Group

Etching 21.7 × 26.8 cm. Pub. August 1819 by Richard Dighton (not in BM)
Library of Congress, Prints and Photographs Division

Richard Dighton, the son of Robert Dighton, is best known for his stiff portrait drawings of London celebrities. Elaborate military costumes figure largely in this assemblage of comic types.

142 · GEORGE CRUIKSHANK (1792–1878)

The Queen's Matrimonial Ladder: A National Toy

Woodcut (total length 31 × 6 cm, boundary lines). Pub. William Hone, 1820
David Bindman Collection

This cardboard 'toy' was issued with a pamphlet published by the radical William Hone at the time of Queen Caroline's trial. Each step illustrates a stage in the progressive moral degradation of the Prince Regent.

143 · ISAAC ROBERT CRUIKSHANK (1786–1856)

Reflection, To Be, or Not to Be? pl. 50

Hand-coloured etching 30.5 × 22.7 cm. Pub. 11 February 1820 (BM 13661)
Library of Congress, Prints and Photographs Division

On 31 January 1820 the Prince Regent acceded to the throne. An urgent consideration was the status of his estranged Consort, Queen Caroline, whose private life had been the subject of a secret investigation. Efforts to secure a divorce were defeated on 10 February. This print, issued the following day, shows the King startled by the reflection in a mirror of his wife, already crowned. Eventually, a bill introduced to the House of Lords to deprive the Queen of her title and rights was withdrawn, although the so-called 'trial' aroused a virulent assault on the Ministry. An American noted: 'The most remarkable aspect of this fierce encounter was the boundless rage of the press [which] every day produced its thousand fiery libels against the king . . . and as many caricatures.'

144 · EDWARD FRANCIS BURNEY (1760–1848)

Amateurs of Tye-Wig Music c. 1820, pl. XVII

Watercolour and pen and ink 48.4 × 71.9 cm
Yale Center for British Art, Paul Mellon Collection, B1975.3.155

Burney was mainly a book illustrator, but his finest work is found in a small group of detailed caricature scenes, of which this is the most elaborate. Using every conceivable refinement of detail, it mocks the absurdities of musicians and amateurs who ignored the claims of modern composers, and devoted their attention to those of the past, notably Handel. No doubt Burney had in mind such societies as the Academy of Ancient Music, and the Concert of Ancient Music, to which he himself belonged. Burney was the nephew of the great musicologist Charles Burney, and had provided illustrations to his book about the Handel Commemoration in 1785. The design has its roots in the controversy aroused in 1776 when his uncle and Sir John Hawkins had published rival histories of music. The former extolled the virtues of contemporary music, and the latter claimed that music had begun to decline at the beginning of the seventeenth century. A hideous cacophony is created by the performers, who all use different scores. The fire is fed with the manuscripts of Mozart, Beethoven and Haydn, and in the foreground a caricature shows Beethoven being taken to Bedlam in the 'cart' Rasoumoffsky. Handel is enshrined, and the walls are covered with portraits of composers, and with characters from the mythology of music such as Midas and Orpheus.

145 · THEODORE LANE (1800–28)

Snug in the Gallery, plate 3 from *Theatrical Pleasures*

Hand-coloured etching
Pub. 1 January 1822 by G. Humphrey, 27 St. James's Street (not in BM)
Library of Congress, Prints and Photographs Division

Lane's *Theatrical Pleasures* (6 plates) record the tribulations of attending a Regency performance. In the same year, he also etched a series of six plates illustrating the actors travails. A social humourist of promise, Lane died tragically after falling through a skylight.

146 · M. EGERTON (*fl.* 1821–28), etched by G. Hunt

A Real Rubber! At Whist

Hand-coloured aquatint 35.7 × 29 cm (clipped impression). Pub. *c.* 1825 (BM 15005)
Lewis Walpole Library

147 · THEODORE LANE (1800–28)

Reflections on Matrimony, The Honey Moon, and Afterwards pl. XVIII

Hand-coloured aquatint 53.5 × 40.2 cm. Pub. by Thomas McLean, 1827 (not in BM)
Andrew Edmunds Collection

148 · ROBERT SEYMOUR (1798–1836)

The Turnip Field

Hand-coloured etching. Pub. 11 March 1830 (not in BM)
New York Public Library, Astor, Lenox and Tilden Foundation

After abandoning his early interest in history painting, Seymour turned his attention to comic illustration in the manner of George Cruikshank, specializing in humorous sporting subjects. His reputation in this genre prompted the publishers, Chapman and Hall, to commission the text of *Pickwick Papers* from Charles Dickens to accompany Seymour's illustrations.

149 · WILLIAM HEATH (*c.* 179–1840)

The PRIME Lobster pl. 51 ▷

Hand-coloured etching 37.5 × 26 cm. Pub. *c.* January 1828 (BM 15500)
Library of Congress, Prints and Photographs Division

Because of their red uniforms English soldiers were frequently known as 'lobsters'. The Duke of Wellington had recently become Prime Minister and had reluctantly agreed to resign as Commander-in-Chief. From his back hangs the Chancellor of the Exchequer's gown. Vastly productive in the 1820s, Heath was at this date using the pseudonym of 'Paul Pry', represented by the little figure in the left hand corner.

150 · ANONYMOUS

Present Mode of Applying a Pitch Plaister!! pl. XIX

Hand-coloured etching, with ink inscription, 38.1 × 25 cm (clipped impression).
Pub. 1828 by T. Tregear, Cheapside, London (not in BM)
Library of Congress, Prints and Photographs Division

On the plaster is the pen and ink inscription 'Catholic Emancipation, Prepared by Wellington, Peel & Co'. A ragged Irishman slaps the plaster on the face of a figure

The PRIME Lobster

PL 51

whose distinctive costume identifies him as John Fane, 10th Earl of Westmorland. He was among the many reactionary Tory ministers to resign after the King had asked Canning to form a Government in April 1827. The burning issue of the day was Catholic Emancipation, and it was feared that without it there would be civil war in Ireland, where the Catholic Association founded by Daniel O'Connell had a large following. In 1829 the Catholic Emancipation Bill was finally passed through by Peel and Wellington, and 16 Catholic MPs were admitted to Parliament in 1830. The artist of this outstandingly original caricature is difficult to identify, and has signed the plate with the pseudonym 'Dickey Fubs'. The pseudonym has been associated with Henry Heath, although the quality of his work is not usually as high as this.

151 · CHARLES JAMESON GRANT (fl. 1828-46)

The Cause of the Present State of the Nation

Hand-coloured etching 29.3 × 38.7 cm (clipped impression)
Pub. February 1831 by S. Gans, Southampton Street, Covent Garden (not in BM)
David Bindman Collection

In this variation on the popular caricature subject of the 'Four Alls', the poor man is pinched by the manufacturer, who is pinched by the Landlord, who is pinched by the taxgatherer, who is pinched by the Devil. A gifted but neglected artist, the scope of Grant's activities became evident when his own volume of collected prints was recently discovered. This example is from the broken up volume. Violently radical in his views, Grant progressed from etching (also designing plates which William Heath signed), to lithography, and finally to cheap crude woodcuts.

152 · HENRY HEATH (fl. 1824-50)

The Revolution of 1831

Hand-coloured etching 23.6 × 33.3 cm. Pub. May 1831 (BM 16690)
Library of Congress, Prints and Photographs Division

Agitation for Reform swelled to menacing proportions in 1831. On 1 March, the Whig administration under Lords Grey and Russell introduced the 'Great Reform Bill' which would ultimately disenfranchise 56 'rotten' boroughs and increase the power of the middle classes. Lord Grey encouraged by William IV is shown sweeping the rats from their 'burrows'. Leading the fight is Sir Charles Wetherell, MP for Boroughbridge which was considered the epitome of corruption. Caricatures dealing with the Reform Bill represent the last flourish of the traditional hand-coloured etching, soon to become obsolete.

153 · CHARLES JAMESON GRANT (fl. 1828-46)

Carrion Crows in John Bull's Cornfield pl. 52

Hand-coloured lithograph, with some scratching out, 27.2 × 41.9 cm (clipped impression)
Pub. July 1832 by Tregear, 123 Cheapside, London (not in BM). Richard Godfrey Collection

Radical and bitterly anti-establishment, Grant reserved special venom for the police and the clergy. The efflorescent noses of the clergymen descending to feed off their tithes are a typical feature of his work, which formed one of the most vivid and bad tempered contributions to the controversy surrounding Reform. This example is from Grant's own album of his work.

PL. 52

154 · CHARLES JAMESON GRANT (*fl.* 1828–46)

Reviewing the Blue Devils, Alias the Raw Lobsters, Alias the Bludgeon Men.
The Political Drama. No. II 1833

Woodcut 22.1 × 34 cm. David Bindman Collection

The Metropolitan Police force was established by Sir Robert Peel in 1829, and was initially very unpopular, its early recruits having a poor reputation. Grant was from the start almost pathologically opposed to the police, whom he represents here as violent and loutish. The crude woodcuts of the Political Drama, printed on the cheapest paper, were aimed at a wide audience and represent Grant's most sustained effort, 131 prints being issued.

CARICATURE AND COMIC ART OF
THE VICTORIAN AGE

During the long reign of Queen Victoria, comedy was to supplant satire as the dominant feature of English visual humour. Caricature suffered the sea change of a channel crossing, but Daumier's satiric powers were alien to English artists, who saw themselves increasingly as humorous illustrators and comic draughtsmen. John Leech most clearly embodied the change in the early years of *Punch*, which saw the

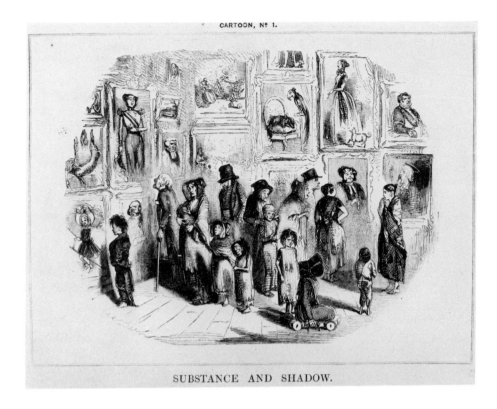

Fig. 1. John Leech, *Substance and Shadow*. Cartoon, No. 1, *Punch* 1843.

word 'cartoon' introduced into the language in the modern sense of a humorous drawing. The usage arose from a competition to supply the new Houses of Parliament with historical frescoes. The large rough designs or 'cartoons' were exhibited, Leech saw the opportunity for a series of biting satires (fig. 1), and the new usage stuck. *Punch* rapidly became a national institution in which cartoons and 'socials' — humorous illustrations to jokes dealing with differing aspects of the social scene, vied with, and often swamped, political or satiric comment. But while Leech, and his successors Keene, Du Maurier and Phil May mirrored the foibles of the age, political caricature became increasingly the voice of the establishment, instead of its scourge, in Tenniel's elaborate weekly allegories which expressed national attitudes for over half a century. While the *Punch* team reigned supreme, W.C. Baxter in a cheap and vulgar halfpenny paper produced the quintessential working class figure of Ally Sloper, the prototype of the mythical characters of the comic strip, while in *Vanity Fair* Leslie Ward perfected his vignettes of the upper crust. It was Max Beerbohm's achievement to develop the *Vanity Fair* style into a unique weapon for dissecting not only of the personalities of the present but the past, and, by so doing, to give caricature yet another dimension.

155 · ALFRED EDWARD CHALON (1761–1860)

Violante Camporese, 1829

Watercolour 33 × 22.6 cm. Victoria and Albert Museum, E 963–1924

La Camporese (1785–1839) was an Italian soprano who sang in London from 1817. She is depicted performing at her Benefit concert on 12 June 1829, her last public appearance. Chalon, an artist and miniature painter, enjoyed caricaturing prima donnas and ballerinas.

156 · JOHN DOYLE ('HB') (1797–1868)

High Bred – Low Bred . . . Remarkable Animals in Brook's Menagerie pl. 53

Lithograph 28 × 37 cm. Pub. 11 December 1835. Victoria and Albert Museum, E99–1923

Doyle's genteel humour, which epitomized the transition to Victorian propriety, often depended on subtle allusions. In this image, Sir Edwin Landseer's paintings of an aristocratic greyhound and a plebeian bull terrier were transformed into Lord

PL 53

John Russell, Prime Minister, and Daniel O'Connell, the Irish patriot, who had clashed at Brook's Club.

157 · GEORGE CRUIKSHANK (1792-1878)

The Railway Dragon, from *George Cruikshank's Table Book* (London, 1845)
Etching 27 × 19 cm. Victoria and Albert Museum 9384.12

George Cruikshank's Table Book was intended as a family periodical containing a variety of humorous social and political subjects. It was issued in monthly instalments with illustrations by the artist. The 1840s was a decade of railway mania with Parliament authorizing railway companies to raise vast amounts of capital to subsidize a major rail network in England. Wild speculation in railway shares in 1845 contributed largely to a financial panic in 1847. The ruin of many private fortunes was predicted by Cruikshank in this design showing a ravenous steam engine devouring a family's dinner.

158 · ALFRED HENRY FORRESTIER ('ALFRED CROWQUILL') (1804-72)

Bill Poster Effects c. 1840, pl. XX
Pen and ink and watercolour 26.3 × 20.5 cm. Victoria and Albert Museum, E 258-1948

'Crowquill' had a long and successful career, at first as writer and caricaturist, later as an illustrator. This image exploits the idea of a chance juxtaposition of posters on a public wall. Wellington, for instance, sports a dancer's body.

159 · JOHN LEECH (1817-64)

A Brilliant Idea
Oil on Canvas 49.5 × 40 cm. Pub. *Punch's Almanack* 1855
Victoria and Albert Museum E.1839-1946

Leech was a regular contributor to *Punch* from about 1841. He made political cartoons, but the popularity of his innocuous social humour marks a change in emphasis from the sharper satire of the earlier caricature tradition. Leech's eye was everywhere, and the three volumes of his collected works for *Punch* provide a microcosm of High Victorian social life of inexhaustible variety. He, more than anyone else, was responsible for establishing a tradition of social humour which has continued from his day to the present cartoons of Giles in the *Daily Express*.

160 · WILLIAM MAKEPEACE THACKERAY (1811–63)

A Tea Table Tragedy

Watercolour and pen and ink 10.3 × 9.1 cm. Pub. *Punch* 1846
Victoria and Albert Museum, P15-1952

The design was published with the following caption: Miss Potts: Married her Uncle's black footman, as I'm a sinful woman.
Mrs Totts: No?
Mrs Watts: Oh!
Miss Watts: Law!!

Novelist, critic and illustrator of many of his own works, Thackeray was in some respects a frustrated artist, and his published observations on art and caricature are very perceptive.

161 · RICHARD DOYLE (1824–83)

Brown, Jones and Robinson in the Highlands c. 1850

Wood engraving 32.3 × 40.5 cm. Victoria and Albert Museum E8827-1905

These vignettes, relating the mishaps of three bachelors deerstalking in Scotland, were intended to illustrate an unpublished sequel to Doyle's popular *The Foreign Tour of Brown, Jones and Robinson* (*Punch* 1850). Doyle, the son of John Doyle, resigned from *Punch* in 1850 to devote his energies to book illustration and the painting of fairy subjects.

162 · EDWARD LEAR (1812–88)

Self-portrait pl. 54

Pen and ink 6.1 × 12.7 cm. Allan Cuthbertson Collection

PL 54

Lear was an ornithological and topographical draughtsman, but he achieved greater fame as author of *A Book of Nonsense*, published in 1846, and of other comic verse. His perverse delight in his own imagined ugliness showed itself in many self-portrait caricatures.

163 · SIR JOHN TENNIEL (1828-1914)

The British Lions Vengeance on the Bengal Tiger

Watercolour. Pub. *Punch* 22 August 1857. Draper Hill Collection

Published during the Indian Mutiny the cartoon on which this watercolour is based became a famous anthropomorphic image. Such visual metaphors came easily to Tenniel who began his career illustrating *Aesop's Fables*. He joined the staff of *Punch* in 1851 and succeeded John Leech as chief cartoonist in 1864. For nearly half a century he gave form to the solemn political views of the *Punch* editorial table, producing over 2000 cartoons for the magazine.

164 · SIR JOHN TENNIEL (1820-1914)

Dropping the Pilot

Wood engraving. Pub. *Punch* 29 March 1890

This celebrated cartoon shows the dismissed Bismarck leaving the ship watched impassively by the Kaiser.

165 · ERNEST GRISET (1843-1907)

Professor Richard Owen and Mr. Bryce-Wright

Watercolour and pen and ink (a pair) each 22.8 × 30.4 cm
Victoria and Albert Museum, E777, E778-1948

Griset, who specialized in caricaturing natural history themes, satirizes in these drawings Owen's work as a palaeontologist, and his delight in jaw-breaking Latin names.

166 · CHARLES KEENE (1823-91)

The Cheap Fares

Pen and ink 14 × 20.1 cm. Pub. in *Punch* 3 May 1890
Yale Center for British Art, Paul Mellon Collection

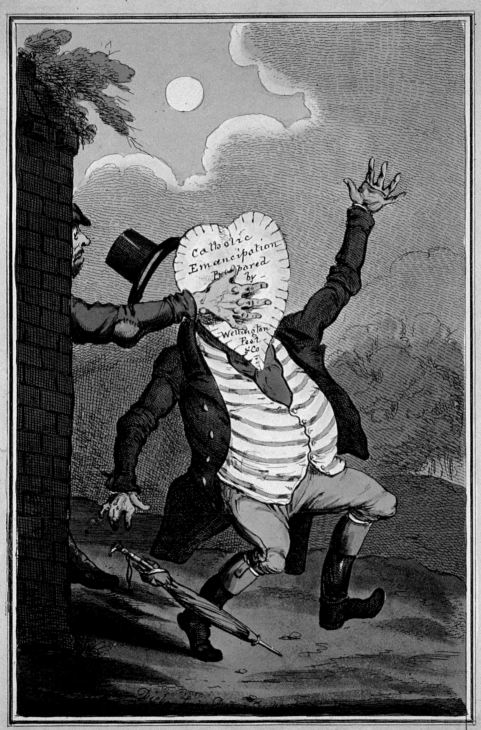

Present Mode of Applying a Pitch Plaister!!

Pubd 1829 by T Tregear Cheapside London.

XIX (CAT. 150)

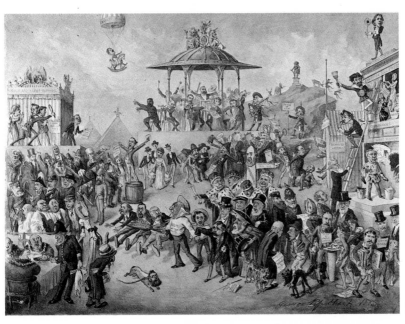

XXI (CAT. 170)

XX (CAT. 158)

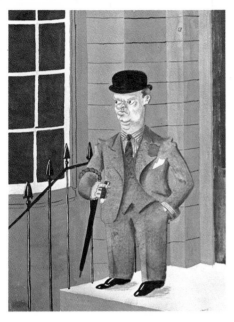

XXIII (CAT. 185)

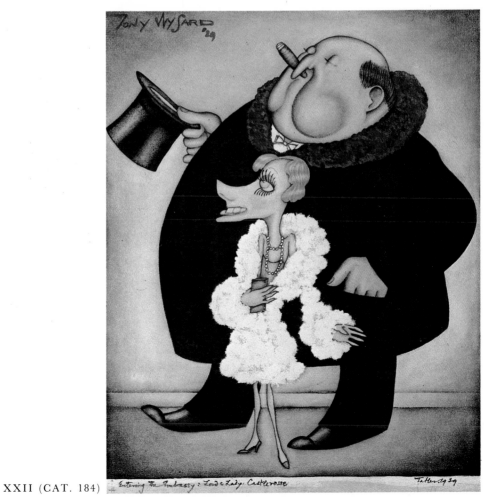

XXII (CAT. 184)

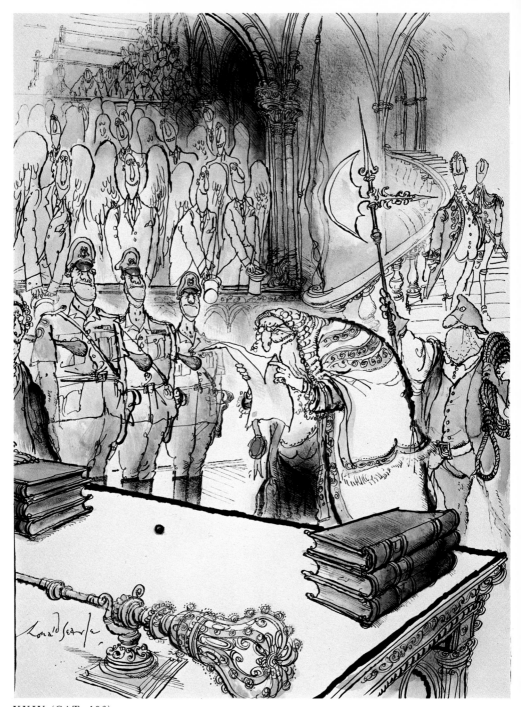

XXIV (CAT. 196)

'*Passengers.* "We're full. There's no Room!"
Conductor. "We Must Make Room For 'Er. There's Room For One on The Near
Side 'Ere. B'sides You're All Short Penn'orths, And She's a Fourpenn'orth —
Goes The Whole Way".'

Keene contributed to *Punch* for many years. The jokes are often weak, and the
caricature mild, but they form a wonderful commentary on the passing details of
Victorian life. His draughtsmanship was superb, and much admired by Degas,
Pissarro, Menzel, Whistler and other artists.

167 · GEORGE LOUIS PALMELLA BUSSON DU MAURIER (1834–96)

The Height of Aesthetic Exclusiveness pl. 55

Pen and ink 21 × 27.4 cm. Pub. *Punch* 1 November 1879
Victoria and Albert Museum, E396–1948

Du Maurier studied painting in Paris before moving to London where he turned to
book illustration and social caricature in the 1860s. He succeeded Leech at *Punch* as
the chronicler of the Victorian age, charting the fashions and foibles of the Aesthetic
movement and social climbing parvenus. The 'Cimabue Browns', one of his major
creations, were an affected family whose tastes embraced everything fashionable
from Liberty silks to peacock feathers.

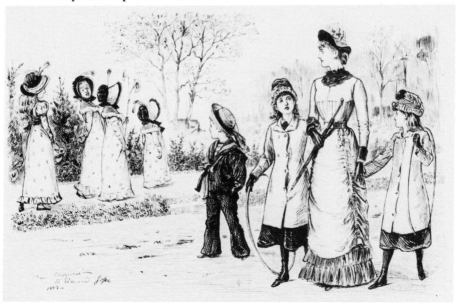

PL 55

168 · SIR EDWARD BURNE-JONES (1833-98)

Back View of William Morris pl. 56

Pencil 18 × 11.5 cm. Victoria and Albert Museum, E449-1976

William Morris reading Poetry to Burne-Jones

Pen and ink 18 × 11.5 cm. Victoria and Albert Museum, E450-1976

Burne-Jones and Morris collaborated on a number of artistic projects. Unlike most of the works in this exhibition, these caricatures were intended only for the enjoyment of friends and correspondents. Hence the ribald depiction of Morris urinating in the first sketch, and the playful suggestion in the second, that his poetry really is tedious.

PL 56

169 · SIR EDWARD LINLEY SAMBOURNE (1844-1910)

Charles Bradlaugh, MP (1833-1911), pl. 57

Pen and ink 15.3 × 15 cm. Pub. *Punch*, 10 September 1881
Victoria and Albert Museum, Gift of Sir Robert Witt CBE. E99-1956

William Booth (1829-1912)

Pen and ink. Pub. *Punch*, 27 October 1883
Victoria and Albert Museum, Gift of Sir Robert Witt CBE. E100-1956

Charles Bradlaugh was a radical politician, pamphleteer and atheist. His refusal to

take the oath of office on first entering Parliament in 1880 led to him being barred, but he was returned by his constituents after a by-election. He is depicted at the height of the controversy as a vampire bat with hornets buzzing round his head — an allusion to his vitriolic rhetoric.

General Booth, founder of the Salvation Army, ascends to Heaven by blowing a French horn, the force of which propels him upwards. The hymn-book recalls his famous remark in reference to popular music-hall songs: 'Why should all the good tunes belong to the Devil?'

Sambourne was on the editorial board of *Punch* from 1871. On Tenniel's retirement in 1901, he became chief caricaturist.

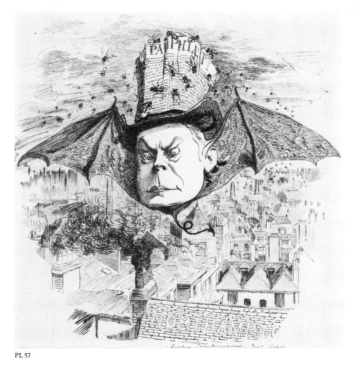

PL 57

170 · JOHN WALLACE ('GEORGE PIPESHANKS')
(*fl.* 1880–95)

Cope's Christmas Card, December 1883 pl. XXI

Watercolour 44.5 × 56.2 cm. Allan Cuthbertson Collection

Some of the more memorable figures are:

In the booth, top left, Ellen Terry stands behind Henry Irving who 'holding the mirror up to nature' falls into the arms of the American actor Edwin Booth. Walt

Whitman leans against the booth below them (*Leaves of Grass* had just been published in London for the first time), with Matthew Arnold to his right. Joseph Chamberlain brandishes the *Free Trade Loaf*, while above them floats the intrepid balloonist Captain Burnaby. In the bandstand the Prince of Wales conducts while Patti sings, and Sir Arthur Sullivan plays the cello. On the left the dethroned Zulu chieftain Cetewayo plays the bones immediately above Lily Langtry who carries two large bags of dollars earned by using her likeness to advertise soap. Beneath the Prince of Wales the two American evangelists Moody and Sankey are impressed by the balance sheet shown to them by the Salvation Army leader General Booth. Below them Lord Salisbury, leader of the Conservative party, is depicted as a signpost sturdily pointing the way, naturally to the right, for the Conservative Peers, while below him Gladstone, Grand Old Man of the Liberal Party, dressed as a sailor, leads Lord Randolph Churchill, dressed in Disraeli's discarded coat, by the arm. In front of this group the 'Orange' and 'Nationalist' Kilkenny cats fight out the eternal battle of the Irish question, while Parnell, bearing a placard 'Pity the Poor Landlords' (a satirical reference to the boycotting activities of the Land League) receives offerings from the Catholic church and starving peasantry. On the right the School of Art Advertising, is surmounted by Oscar Wilde, sunflower in hand. Below the ladder leaning on the School, Millais gazes up at Ruskin who stands on the first rung of the ladder. Above him sits Whistler, disconsolately playing a penny whistle. At the top of the ladder Herkomer brandishes a large paint brush. On a distant hill stands a statue of John Brown, Queen Victoria's favourite Highland servant, who had just died, surrounded by deer and ghillies.

171 · SIR LESLIE WARD ('SPY') (1851–1922)

Anthony Trollope

Watercolour 28.2 × 18.4 cm. Pub. *Vanity Fair*, 1 April 1873
National Portrait Gallery, London

In 1873, Ward began working for *Vanity Fair*, a society magazine founded in 1868, which published a weekly caricature of a celebrity. Over the next forty years 'Spy' contributed nearly half of its 2400 caricatures. This portrait of Anthony Trollope (1815–82) infuriated the famous novelist.

172 · WILLIAM GILES BAXTER (1856–88)

The Russian Bear 1887, pl. 58

Pen and brush and ink 25 × 32.6 cm. Victoria and Albert Museum D 139–1906

One of the most popular inventions of Victorian humour was the character Ally Sloper, a gin-swilling, bottle-nosed lout who exaggerated the prejudices and interests

of the working classes. Originally a literary creation, Sloper was given a pictorial existence by William Baxter for the comic newspaper *Ally Sloper's Half Holiday*, founded in 1884. Three years later, the Narodnaya Volga group attempted to blow up Alexander III of Russia, an event leading to the execution of Lenin's brother. In this satire, Sloper, visiting the zoo, contemptuously offers a Russian bear a bomb, while the Tsar, the Kaiser and Bismarck watch impassively.

PL 58

173 · HARRY FURNISS (1854–1925)

Imitation, the sincerest flattery pl. 59

Pen and ink 24.1 × 18.6 cm. Pub. *Punch* 23 August 1890
Victoria and Albert Museum, E513–1931

The Irish members in Gladstone's last administration were a small but vocal group, much prone to filibustering. Shown here are the principal figures in all three party groups apeing the gestures of their party leaders during a protracted session of the House of Commons. Gladstone sits resolutely upright, with Joseph Chamberlain and other leading Liberals imitating his pose. On the opposition benches recline the languid forms of Conservative leader A.J. Balfour and his Tories. At the bottom the gesticulating figures of Tom Healy and other impassioned Irish orators.

PL 59

174 · PHILIP WILLIAM MAY (1864–1903)

SO LIKELY!

Red chalk 35 × 24.5 cm. Pub. *Punch* 1895. Victoria and Albert Museum

Scene — Bar of a Railway Refreshment Room.
Barmaid. 'Tea, Sir?'
Mr. Boozy. 'Tea!!! Me!!!!'

May's early success as a social humourist resulted in his appointment to the famous editorial table of *Punch* in 1895, the year that he made this drawing. It depicts an old soak alarmed at the prospect of having to drink tea. The drawing was a gift from May to his friend and fellow artist Charles Conder. A flamboyant spendthrift, May died of cirrhosis of the liver in 1903.

PL 60 PL 62

175 · ALFRED BRICE ('Grip') (active 1893–96)

Aubrey Beardsley

Grey wash heightened with white 29 × 14.5 cm. Pub. *The Sketch*, 1896

Rudyard Kipling pl. 60

Grey wash heightened with white 25.3 × 13.5 cm
Pub. *The Sketch*, 1896 as Mr Rudyard Kipling Atkins
Victoria and Albert Museum E747-1948, E3947-1914

Beardsley, the high priest of Art Nouveau, and Rudyard Kipling, the robust proselitizer of the Empire, were at the height of their fame in 1896. Kipling's attitude to aesthetes such as Beardsley was committed to verse in 1890:

It's Oh to meet an Army man,
Set up, and trimmed and tout,
Who does not spout hushed libraries
Or think the next man's thought,
And walked as though he owned himself,
And hogs his bristles short.

176 · SIR FRANCIS CARRUTHERS GOULD (1844–1925)

The Wonderland Parliament, Off to the Opening

Pen and ink 19.7 × 30.7 cm. Pub. *Westminster Gazette*, 16 January 1902

Alice anywhere by in Downing Street, Alice and the two Queens

Pen and ink 10.1 × 15.6 cm. Pub. *Westminster Gazette*, 11 October 1901
Victoria and Albert Museum E1042–1948, E1040–1931

Gould was the first staff caricaturist on a daily British paper, working for the *Westminster Gazette* from 1894 to 1914. In *The Westminster Alice*, a collaborative effort with H.H. Munro ('Saki'), he employed Lewis Carroll's famous characters to parody such politicians as A.J. Balfour and Joseph Chamberlain. Chamberlain viewed Gould's caricatures of him as 'works of imaginative art', and he congratulated the artist 'on adding another interesting personality to the gallery of English fiction'.

177 · LEONARD RAVEN-HILL (1867–1942)

Reciprocity pl. 61

Pen and ink 26.7 × 40.5 cm. Pub. *Punch*, 1 March 1911
Victoria and Albert Museum, E583-1913

This reference to the tariff barriers which caused friction between the United States
and Canada, was originally published with the inscription:

Moose: 'That's all right, my dear fellow, I knew it was only your chaff when you
talked of swallowing me, and of course I too never seriously thought of
swallowing *you!*'

In 1895 Raven Hill joined the staff of *Punch* where, for forty years, he was to work
with Bernard Partridge.

178 · SIR MAX BEERBOHM (1872–1956)

William Schwenk Gilbert pl. 62

Pen and ink 32.4 × 20.2 cm. Pub. *Pick-me-up*, 27 October 1894. Allan Cuthbertson Collection

Beerbohm was one of the most original caricaturists of his generation, and a writer
and dramatic critic. Sir William Gilbert (1836–1911), one of Beerbohm's 'minor
gods', was the lyricist of numerous operettas written in collaboration with Sir Arthur
Sullivan. A combative wit and master of repartee, Gilbert once claimed that 'all
humour properly so-called is based upon a grave and quasi-respectful treatment of
the ludicrous'.

179 · SIR MAX BEERBOHM (1872–1956)

Mr H.G. Wells and His Patent Mechanical New Republic c. 1903

Pen and ink and grey wash. Pub. *The Sketch* 21 October 1903
Beinecke Rare Book and Manuscript Library, Yale University

Herbert George Wells (1866–1946), social historian, and author of such prophetic
novels as *The Time Machine,* was a favourite target of Beerbohm. This early
caricature was inspired by Wells' recently published *Anticipations of the Reaction of
Mechanical and Scientific Progress upon Human Life and Thought* (1902). Wells had
envisaged a totally mechanized socialist 'world state', in which the rational spirit of
Science would dominate all human affairs. Max ridicules the idea, by having a sickly
figure of Pure Reason mechanically crown Wells as President of this new Urban
Society.

180 · HENRI GAUDIER-BRZESKA (1891–1915)

Lord Alfred Bruce Douglas 1913, pl. 63

Brush and ink 30.5 × 17.8 cm. Allan Cuthbertson Collection

Lord Alfred Douglas (1870–1945), third son of the Marquis of Queensberry, was a minor poet with a dissolute and vindictive character. His later life was overshadowed by the scandal of 1895, when his intimate companion Oscar Wilde sued Douglas's father for libel, lost the case and was subsequently tried and imprisoned for homosexual offences. Gaudier-Brzeska, sculptor and friend of Ezra Pound, rarely drew caricatures. This example is from the year that Douglas was sued for libelling his own father-in-law.

PL 63 PL 64

THE TWENTIETH CENTURY

Above all, the twentieth century is the age of the newspaper cartoonist, embodied in Britain by the sustained intelligence and insight of David Low. The modern cartoonist lacks the technical opportunities of Gillray, particularly colour, and much of his licence, but this is compensated for by the vast increase in the size of his potential audience, which, with world wide syndication, can reach scores of millions. Required to respond daily to changing events, he must acquire a strong simple style

which can be used with journalistic regularity. The cartoonist's scope has been enlarged by the development of the strip cartoon, earlier anticipated by some eighteenth-century artists, and by the availability of photographs and film. Until the 1960s, the potential virulence of personal caricature was kept within limits, but the exuberant drawings of Steadman and Scarfe then re-introduced some of the old ferocity of spirit.

181 · BRUCE BAIRNSFATHER (1888–1959)

One of Our Minor Wars. "Well, If You Knows Of A Better 'Ole, Go To It!" pl. 64

Ink and gouache 33.7 × 24 cm. Pub. *The Bystander*, Christmas 1915
Tonie and Valmai Holt Collection

One of the most famous cartoons of the First World War, which sums up the predicament of the soldier on the Western Front. Bairnsfather's cartoons and his famous creation 'Old Bill' gained international popularity, although his scruffy Tommies, grumbling but enduring, did not always gain official approval. A Captain in the Royal Warwickshire Regiment, Bairnsfather was badly wounded in the Second Battle of Ypres in 1915.

182 · SIR BERNARD PARTRIDGE (1861–1945)

The Kindest Cut of All
Pub. *Punch* 10 March 1920

The Irish problem was acute in the years following the end of the First World War. Lloyd George advocated an all Irish Council to function within the United Kingdom, with separate parliaments for the mainly Protestant counties of Ulster, and the Catholic southern counties. Reluctantly accepted by the North, this was accepted by the South, and violence followed in the subsequent 'Anglo-Irish war'. Partridge drew many of *Punch*'s political 'cuts' from 1901 until his death.

183 · HENRY MAYO BATEMAN (1887–1970)

Getting a Document Stamped at Somerset House
Pen and ink on four separate sheets. Each sheet 39.4 × 30.5 cm
Pub. *The Tatler* 30 November 1923. H.M. Bateman Estate

Bateman was the most original exponent of the strip cartoon in Britain, and the present example is not only a comprehensive essay on bureaucracy, which he hated, but an outstanding example of black and white work. The innocent citizen begins his day with complacency (top left), spends it in confusion, and ends it with suicide.

184 · ANTONY WYSARD (b. 1907)

Entering the Embassy: Lord and Lady Castlerosse pl. XXII

Pencil, crayon, water colour and gouache 26.9 × 22.3 cm. Pub. The *Tatler*, 1929
Sir Osbert Lancaster Collection

Lord Castlerosse (1891–1943) was a celebrated socialite, *bon viveur*, and gossip columnist for the *Sunday Express*. The first Lady Castlerosse was Doris Delavigne (1900–42), a noted beauty, who here accompanies her husband to the Embassy Club. Wysard's stylized caricatures of social figures appeared regularly from 1928 in the *Tatler* and other magazines.

185 · SIR OSBERT LANCASTER (b. 1908)

Mr. Evelyn Waugh reacting strongly to the Century of the Common Man pl. XXIII

Watercolour 25 × 17.2 cm. Pub. *Strand* Magazine, 1947. Septimus Waugh Collection

In a letter to John Betjeman, Waugh wrote: 'O. Lancaster's sketch good in conception but poor in execution'. He is shown on the steps of White's Club which he frequented regularly. At this period Waugh had just returned from California to discuss a possible film of *Brideshead Revisited* (never made) and was about to start writing *The Loved One*. A close friend of the novelist, Lancaster was for many years the contributor of a brilliant pocket cartoon to the *Daily Express* and is also a stage designer, and the author and illustrator of numerous celebrated books on architecture and design.

186 · WILL DYSON (1880–1938)

The Gold Digger

Brush and ink 47.6 × 39.7 cm. Pub. *Daily Herald*, 1935
Centre for the Study of Cartoons and Caricature, University of Kent, Canterbury

The worldly figure of Mae West embodies the prosperity of the armaments industry as she strides away from the abandoned figure of Peace. Dyson was an Australian who worked on the *Sydney Bulletin* before coming to England in 1909. Much of his career was spent with the socialist *Daily Herald*, and although his best work was from his early years, he always drew with great power.

LOW'S TOPICAL BUDGET

EMPIRE EXHIB'N SENSATION.
Interest has been aroused at Glasgow by the Isolation exhibit which illustrates the detachment of Lord Beaverbrook. Of course we wind him in for meals.

"BRIGHTEN UP SCOTLAND"
(Exhibition suggestion)

Opinion is far from unanimous about the decency of hanging out bunting. Fears are expressed that folk would be dancing next.

LET'S GET THIS STRAIGHT
Certain local authorities wish it to be distinctly understood that whatever happens in connection with future wars they will not pay for it.

CARTOONISTS TO WEAR UNIFORM?
So Hitler has put all his journalists into uniform, and cartoonists will be next. O.K. to Low, provided he can roll up to work mounted on a white horse.

AMERICAN CIVIL WAR
A flying column of outraged U.S. debs almost captured Ambassador Kennedy yesterday near Buckingham Palace. The Kennedy family counter-attacked and defeated the enemy by sheer weight of numbers.

Gad, sir, Lord B. is right. No more German refugees. We Anglo-Saxons must keep our blood pure from Germans.

BLIMP

MUZZLER THE DICTATOR
PERPETUAL SALUTE

PL 65

187 · SIR DAVID LOW (1891–1963)

Low's Topical Budget pl. 65

Brush and ink and blue crayon 56.8 × 40.2 cm. Pub. *Evening Standard* 7 May 1938
Centre for the Study of Cartoons and Caricature, University of Kent, Canterbury

The 'Topical Budget' was a regular Saturday feature in which Low filled a page with small cartoons. This was the birthplace of the celebrated Colonel Blimp, an embodiment of the extreme reactionary, depicted by Low each week uttering a nonsensical aphorism, always prefixed by the phrase 'Gad, sir'. One of the figures shown here is Joseph Kennedy, the American Ambassador, who runs from a 'column of outraged U.S. debs'. He had recently ended as 'undemocratic' the custom of presenting at Court the daughters of socially eminent American families.

188 · SIR DAVID LOW (1891–1963)

Which Backbone Shall I Lay Out This Morning, My Lord?' pl. 66

Brush and ink with blue crayon 35.5 × 53.7 cm. Pub. *Evening Standard*, 1 August 1938
Centre for the Study of Cartoons and Caricature, University of Kent, Canterbury

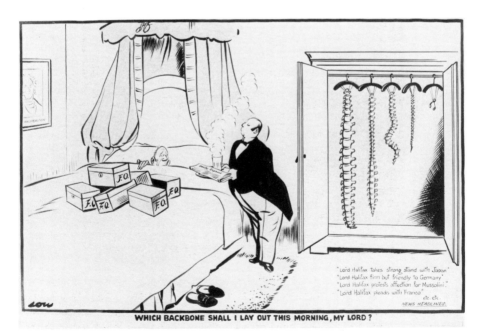

WHICH BACKBONE SHALL I LAY OUT THIS MORNING, MY LORD ?

PL 66

Lord Halifax, Foreign Secretary in Chamberlain's Conservative Government, is in a bed laden with Foreign Office boxes. His timid demeanour is contrasted with the self-confident portrait of Palmerston, a notably aggressive Foreign Secretary and Prime Minister. Appeasement was in the air, and two months later Chamberlain signed the Munich agreement with Hitler. Low, a New Zealander, came to England in 1919 and spent much of his career as political cartoonist of the *Evening Standard*, which, like the *Daily Express*, was owned by Lord Beaverbrook. The editorial policy of the papers was Conservative, and Low was a socialist, but Beaverbrook gave him a free hand. The model of a political cartoonist, syndicated throughout the world, Low was at his best in the years leading up to the War. His work was not appreciated by the Nazis, and on his return from meetings with Hitler and Goebbels, Lord Halifax (at their request) asked Low to moderate his attacks on the dictators in the interests of peace.

189 · SIR DAVID LOW (1891–1963)

"Will You Take my IOU?" pl. 67

Pen and ink 36.9 × 42.5 cm. Pub. *Evening Standard*, 22 September 1944
Centre for the Study of Cartoons and Caricature, University of Kent, Canterbury

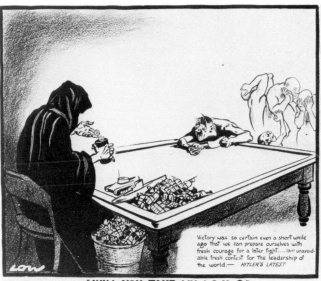

Victory was so certain even a short while ago that we can prepare ourselves with fresh courage for a later fight.... (an) unavoidable fresh contest for the leadership of the world.— *HITLER'S LATEST*

" WILL YOU TAKE MY I O U ? "

PL 67

His military assets fast diminishing, a naked Hitler pleads with Death. His Propaganda Minister, Goebbels, raises his hands in despair. Not surprisingly Low's name was on the notorious Gestapo death list of those to be murdered in the event of Britain's defeat.

190 · SIDNEY STRUBE (1891–1956)

Roosevelt's Fireside Chat pl. 68

Pencil, pen and ink and crayon 35.8 × 51.0 cm. Pub. *Daily Express*, 3 January 1941
Centre for the Study of Cartoons and Caricature, University of Kent, Canterbury

John Bull, fighting alone against Germany, gains a degree of comfort from
Roosevelt's 'fireside chat' of 29 December 1940, when he declared that the United
States must become 'the great arsenal of democracy'. Although his reputation has
been overshadowed by that of Low, Strube was for thirty-six years the political
cartoonist of the Daily Express and enjoyed enormous popularity.

PL 68

191 · GRAHAM LAIDLER ('PONT') (1908–40)

The British Character. Importance of Not being an alien. pl. 69

Pen and ink with pencil 19.9 × 27.9 cm. Pub. *Punch*, 15 April 1936. John Jensen Collection

From April 1934 until his premature death 'Pont' contributed 104 drawings to *Punch*
on the subject of the British character, and popular clichés about it. The
shortcomings of the inoffensive alien include a black tie when white was obligatory.

PL 69

192 · MICHAEL CUMMINGS (b. 1919)

"Oh, Selwyn, wouldn't it be grand if we could vote for Captain too!"

Ink, wash and process white 20.9 × 35.1 cm. Pub. *Daily Express*, 7 November 1960
Centre for the Study of Cartoons and Caricature, University of Kent, Canterbury

John Kennedy narrowly defeated Richard Nixon in the Presidential election of 9
November. Shortly before, the Prime Minister Harold Macmillan, seen here with
Selwyn Lloyd, had announced that Britain would provide sheltered anchorages for
American Polaris submarines. Cummings has been the political cartoonist of the
Daily Express since 1948. His views are strongly Conservative, but he has retained the
right to criticize its leaders.

193 · LESLIE GILBERT ILLINGWORTH (1902-79)

On Target pl. 70

Scraperboard 14.8 × 31.5 cm. Pub. *Daily Mail*, 22 March 1963. Wally Fawkes Collection

President De Gaulle, one of the great targets of post-war caricaturists, is here
depicted as a submarine which having torpedoed Britain's attempts to join the

Common Market, is about to attack NATO. Illingworth was a distinguished draughtsman who was for many years the editorial cartoonist of the *Daily Mail* and a regular contributor to *Punch*. He frequently used scraperboard, a technique involving the scratching of a black-coated board.

PL 70

194 · WALLY FAWKES ('Trog') (b. 1924)

America's Imperial Sunset

Watercolour and gouache 42.2 × 29.8 cm. Pub. *Punch*, 31 May 1972. Artist's Collection

America's Vietnamese predicament is symbolized by the statues of Presidents Kennedy, Johnson and Nixon, which are progressively overgrown by jungle foliage. The image was suggested to the artist by photographs he had seen of statues in India of English monarchs and statesmen, now neglected and overgrown.

195 · RONALD SEARLE (b. 1920)

The Rake's Progress: PUNCH pl. 71 ▷

Pen and ink 49 × 36.6 cm. Pub. *Private Eye*, August 1964. Allan Cuthbertson Collection

Searle's brief but pungent history of the decline of *Punch* into torpor and respectability was commissioned by Malcolm Muggeridge, guest editor for this issue of *Private Eye*. As a previous editor of *Punch*, Muggeridge had injected much needed vitality before being replaced by Bernard Hollowood. Searle's comic and satirical designs and the exuberance of his draughtsmanship have had great influence in England and abroad.

The Rake's Progress: PUNCH

1. Born in penury, 1841. Meagre circulation and impertinent views. Inclined to Republicanism. Queen Victoria, Not Amused. Financial stringency leads to takeover by printers, Bradbury & Evans.

2. Respectability achieved. Captions lengthened. Servants and foreigners good for a laugh. Queen Victoria amused. Thackeray, too drunk to find editorial seat, carves initials on Table.

3. Tenniel Knighted. Partridge Knighted. Queen Victoria Knighted. A.P. Herbert blessed and Knighted. Dog Toby Knighted. Everything great fun. Circulation drops.

4. Muggeridge appointed Editor. Queen Victoria disgusted. Advertisers disgusted. Editorial office disgusted. Regular Readers disgusted. Paper improves. Advertising drops. Muggeridge dropped.

HMS BOUVERIE STREET

5. Dazed by 'sixties. Price increased. Economy cuts in Humour. Hollowood gets 'with it'—starts Women's Page. Homosexuality mentioned twice. PRIVATE EYE lampooned.

6. Hollowood Knighted, Bernard Hollowood knighted, A.B. Hollowood Knighted, B. Hollowood Knighted, A. Hollowood Knighted, Boothroyd Knighted, Thelwell Knighted, Bradbury & Agnew knighted, Publicity Manager Knighted, Doorman knighted. Kate Greenaway Award. 1965.

PL 71

196 · RONALD SEARLE (b. 1920)

SOUTH AFRICA: Colourful Ceremony of Offering Limited Recognition to the Black Grape. From *The Wonderful World of Wine*, 1983, pl. XXIV

Pen, watercolour and crayon 44.5 × 32 cm. Clos du Val Wine Collection

The artist is better known for his scenes of social satire and humour, but he here turns a sharp eye on South Africa and its policy of apartheid. The figure of the judge reflects his deep study of satirical draughtsmen of the past, notably Rowlandson and Gillray.

197 · RONALD SEARLE (b. 1920)

a–e *Fathers of Caricature: William Hogarth, James Gillray, Thomas Rowlandson, George Cruikshank and Edward Lear* 1976–77, pl. 72, p. 141

Engraved bronze (a–d) 8.6 cm diam. (e) 8.1 cm diam.

From a series of medals of caricaturists commissioned by the French Mint.

198 · RALPH STEADMAN (b. 1936)

The Dream of Reason Produces Monsters

Pen and ink with wash 51 × 76 cm. Pub. *Town*, 1968
Artist's Collection (On loan to the Centre for the Study of Cartoons and Caricature, University of Kent, Canterbury)

Inspired by Goya's famous print from *Los Caprichos*, the artist shows himself at his drawing board, surrounded by a swarm of nightmarish figures. On the left is Stokely Carmichael, with Lyndon Johnson above him. On the artist's right is Allan Ginsberg (with glasses and a beard), and above him are Marshall McCluhan, Moshe Dayan, President Nasser, and Harold Wilson. Hovering near the ground are (l. to r.) Mick Jagger, a Red Guard, and George Brown, and flying above them (l. to r.), a mercenary soldier, Maharishi Mahesh Yogi, and the Beatles. A draughtsman of great virtuosity Steadman did much to introduce real bite and vigour into caricatures of the 1960s.

199 · RALPH STEADMAN (b. 1936)

Margaret Thatcher as Churchill, 20 July 1979, pl. 73

Pen, brush and ink 59.5 × 84 cm. Pub. *New Statesman* 27 July 1979

Artist's Collection (On loan to the Centre for the Study of Cartoons and Caricature, University of Kent, Canterbury)

While working in California the artist became wearied by continual American praise of the recently elected Prime Minister, Margaret Thatcher. In September 1983, the Prime Minister visited the United States. At a dinner where she accepted the Churchill Award for services to the North Atlantic Alliance, the following message from President Reagan was read out: 'World affairs today demand the boldness and integrity of a Churchill. In his absence I know he would want us to look to you as the legendary Britannia — a special lady, the greatest defender of the realm. Sincerely, Ron.'

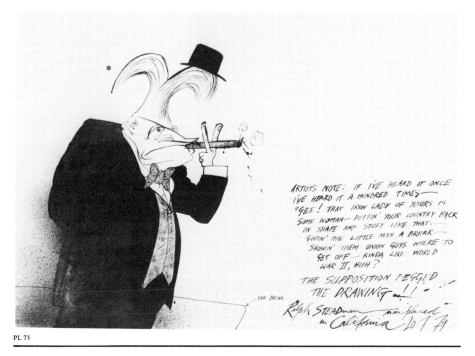

PL 73

200 · DAVID HOCKNEY (b. 1937)

Bedlam Plate 16 from *The Rake's Progress*, 1961–63

Etching and aquatint 30 × 42 cm. Victoria and Albert Museum

Inspired by Hogarth's prints this series is an ironic commentary on the artist's first trip to New York in 1961, with himself in the Rake's role. Hockney noted that: 'When the Rake is first seen in my prints, he is a vivid personality, but little by little he loses this quality. For the last scene, in Bedlam, I did a drawing of a faceless figure, then made a stamp of it that I impressed on the etching plate five times. You see five

faceless people in the madhouse, but you can't tell which one the Rake is. They all wear T-shirts that say "I swing with WABC" and have little radios plugged into their ears. Before that time I had never seen radios like those; they didn't exist in Europe. At first, I thought they were hearing aids; I thought some disease had struck the young of New York.'

The Rake is in fact indicated by a small arrow.

201 · GERALD SCARFE (b. 1936)

Drawing Made in Vietnam – A Soldier by His Bed 1966

Pen and ink. Artist's Collection

While working briefly for the *Daily Mail* the artist was sent to Vietnam to make drawings, and was shocked by his first contact with the confusion of war, although it resulted in some of his finest drawings. The present example is not unsympathetic to the plight of the GI, lonely and vulnerable without his heavy equipment, and is a compelling image of the conscript in modern war, uncertain of his purpose.

202 · GERALD SCARFE (b. 1936)

Mick Jagger and Cecil Beaton pl. 74 ▷

Pen and ink 76.2 × 55.9 cm. Pub. *Private Eye*, 1966. Artist's Collection

An unlikely pairing of the singer and the celebrated photographer, Beaton recorded his impressions of Jagger in several diary entries in 1967: 'His skin is chicken-breast white and of a fine quality. He has an inborn elegance . . . I was fascinated with the thin concave lines of his body, legs and arms. The mouth is almost too large: he is beautiful and ugly, feminine and masculine: a rare phenomenon . . . The lips were of a fantastic roundness, the body almost hairless . . . He is sexy, yet completely sexless. He could nearly be an eunuch.'

The ferocity of Scarfe's caricature and the boldness of his draughtsmanship brought a new dimension to English caricature. Founded in 1961, *Private Eye* eagerly published drawings by Scarfe, Steadman and others, that were unacceptable to other magazines and newspapers.

203 · STEVE BELL (b. 1951)

Maggie's Farm pl. 75

Pen and ink 18.2 × 23 cm. Pub. *City Limits*, 8 April 1982. Victoria and Albert Museum

This strip-cartoon began in 1979, and provides a weekly commentary on Margaret

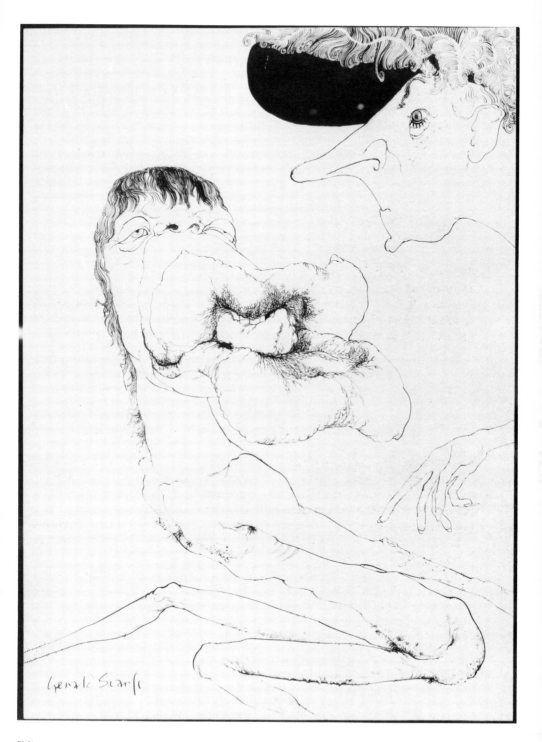

Gerald Scarfe

Thatcher's Government. The 'Farm Government Think Tank' (the Cabinet) is represented here by Geoffrey Howe, Keith Joseph (always shown as a raving lunatic), Norman Tebbit, and Lord Carrington, the Foreign Secretary. On 2 April 1982 Argentina invaded the Falkland Islands; this action had been preceded by the illegal hoisting of the Argentine flag by scrap merchants on the island of South Georgia. The artist was working on this drawing when he heard on the radio that Argentina had invaded, and events bore out his imagination. A force was dispatched to regain the islands, and the subsequent victory helped Mrs Thatcher to win the General Election in 1983.

PL 75

204 · MICHAEL HEATH (b. 1935)

Great Bores of Today. "I used to think divorce would be terrible . . ."
Pen and ink 19.2 × 18.2 cm. Pub. *Private Eye*, 11 September 1981

From a series of drawings which appear regularly in *Private Eye*.

205 · MARK BOXER ('Marc') (b. 1931)

The Prince of Wales 1981, pl. 76

Pen, brush and ink 41.3 × 29.2 cm. Tom Maschler Collection

Under the pseudonym of 'Marc', Boxer is a productive draughtsman of pocket cartoons, often of modish couples, and of caricatures drawn in a spare, linear style.

For Tom from Mark B on the publication of Prince Charming 1981

PL 76

BIBLIOGRAPHY

INDIVIDUAL ARTISTS

Bruce Bairnsfather — *The Best of Fragments from France*, ed. Tonie and Valmai Holt, 1978

F. Barlow — Edward Hodnett, *Francis Barlow: First Master of English Book Illustration*, London 1978

J. Barry — William L. Pressly, *The Life and Art of James Barry*, New Haven and London, 1981

William L. Pressly, *James Barry, the Artist as Hero*, Tate Gallery Exhibition Catalogue, 1983

H.M. Bateman — A. Anderson, *The Man who was H.M. Bateman*, 1982

W.G. Baxter — Sir James Thorpe, 'A Great Comic Draughtsman' in *Print Collector's Quarterly*, 1938, pp. 59–79

Sir Max Beerbohm — R. Hart Davies, Catalogue raisonné, London 1982

M. Boxer — Mark Boxer, *The Trendy Ape*, London 1968

Mark Boxer, *The Times we live in*, London 1978

H.W. Bunbury — John Riely, 'Horace Walpole and "the second Hogarth" ', in *Eighteenth Century Studies*, Autumn 1975, IX, pp. 28–44

Henry William Bunbury, Exhibition Catalogue, Gainsborough's House, 1983. Essay by John Riely, catalogue by Hugh Belsey.

Sir Edward Burne-Jones — Lionel Lambourne, 'Paradox and Significance in Burne-Jones Caricatures', in *Apollo*, November 1975, pp. 329–33

E. F. Burney — P. Crown, *E.F. Burney: An Historical Study in British Romantic Art*, unpub. PhD dissertation, University of California, 1977

G. Cruikshank — G.W. Reid, *Descriptive Catalogue of the Works of George Cruikshank*, London 1871

A.M. Cohn, *George Cruikshank, A Catalogue Raisonné of the Work executed during the Years 1806–77*, London 1924

R.A. Vogler, *Graphic Works of George Cruikshank*, 1979

I. Cruikshank — E.B. Krumbhaar, *Isaac Cruikshank, a Catalogue Raisonné, 1966*

I.R. Cruikshank — W. Bates, *George Cruikshank, the Artist, the Humorist and the Man, with some account of his brother Robert*, 1878

J. Doyle — G.M. Trevelyan, *The Seven Years of William IV, a reign cartooned by John Doyle*, London 1952

R. Doyle — R. Engen, *Richard Doyle*, Stroud (Glos.) 1983

Richard Doyle and his family, Catalogue, Victoria and Albert Museum, 1983–4

W.H. Dyson — J. Jensen, ' "Curious! I seem to hear a child weeping!" Will Dyson 1880–1838', in *20th Century Studies*, No. 13/14, University of Kent, 1975

W. Fawkes — *The World of Trog*, introduction by James Cameron, London 1977

H. Furniss — H. Furniss, *Confessions of a Caricaturist*, London 1901

H. Gaudier-Brzeska — M. Levy, *Henri Gaudier-Brzeska*, London and New York, 1965

J. Gillray — Draper Hill, *Mr Gillray, the Caricaturist*, London 1965

Draper Hill, *The Satirical Etchings of James Gillray*, New York 1976

J. Goupy — R.W. Wallace, 'Joseph Goupy's satire of George Frederic Handel', in *Apollo*, February 1983

S.H. Grimm — R.M. Clay, *Samuel Hiernonymous Grimm*, London 1941

E. Griset — Lionel Lambourne, *Ernest Griset, Fantasies of a Victorian Illustrator*, London 1979

F. Grose — Francis Grose, *Rules for Drawing Caricatures: with an Essay on Comic Painting*, London 1789

W. Hogarth — R. Paulson, *Hogarth: his Life, Art and Times*, (2 vols), New Haven and London 1971

R. Paulson, *Hogarth's Graphic Work*, New Haven and London 1965

D. Bindman, *Hogarth*, London 1981

W. Hollar — R. Pennington, *A Descriptive Catalogue of the Etched Work of Wenceslaus Hollar*, Cambridge 1982

R. de Hooghe — D. Kunzle, *The Early Comic Strip*, 1973, pp. 96-121

L.G. Illingworth — Draper Hill, *Illingworth: On Target*, Boston Public Library, 1970

C.S. Keene — D. Hudson, *Charles Keene*, London 1947

G. Laidler — B. Hollowood, *Pont, The Life and Work of the great Punch artist*, London 1969

E. Lear — A. Davidson, *Edward Lear - Landscape Painter and Nonsense Poet*, London and New York 1938 and 1968

Vivien Noakes, *Edward Lear: the Life of a Wanderer*, London 1968, Boston 1969

J. Leech — S. Houfe, *John Leech and the Victorian Scene*, Antique Collectors' Club 1984

P.J. de Loutherbourg — R. Joppien, *Catalogue of de Loutherbourg Exhibition*, Kenwood 1974

Sir David Low — D. Low, *Low's Autobiography*, London 1956

G.L.P.B. du Maurier — L. Ormond, *George Du Maurier*, London 1969

P.W. May — J. Thorpe, *Phil May, English Masters of Black and White*, 1948

J.H. Mortimer — B. Nicolson, *John Hamilton Mortimer*, Exhibition Catalogue 1968

T. Patch — F.J.B. Watson, *Walpole Society*, XXVIII (1950), 15-50, with catalogue of paintings

A. Pond — L. Lippincott, *Selling Art in Georgian London: the Rise of Arthur Pond*, New Haven and London 1983

J.H. Ramberg — D. Kunzle, *The Early Comic Strip*, 1973, pp. 402-19

Sir Joshua Reynolds — D. Sutton, 'The Roman Caricatures of Reynolds', *Country Life Annual*, 1965, pp. 113-16

T. Rowlandson — J. Grego, *Rowlandson the Caricaturist*, 1880

J. Hayes, *Rowlandson: Watercolours and Drawings*, London 1972

G. Scarfe — *Gerald Scarfe, with an introduction by the artist*, London 1982

R. Searle — *Ronald Searle, with an introduction by Henning Bock and an essay by Pierre Dehaye*, London 1978

R. Steadman — Ralph Steadman, *Between the Eyes*, London 1984

Sir John Tenniel — F. Sarzano, *Sir John Tenniel, English Masters of Black and White*, London 1948

G. Townshend — D. Donald, ' "Calumny and Caricature" : Eighteenth-century Political Prints and the case of George Townshend'; *Art History*, vol. 6, no. 1, March 1983

E. Harris, *The Townshend Album*, National Portrait Gallery 1974

Sir Leslie Ward — R.T. Matthews and P. Mellini in *Vanity Fair*, London and Los Angeles 1982

B. Wilson — H. Randolph, *Life of General Sir Robert Wilson*, London 1862, vol. I, pp. 20-22

GENERAL

Angelo, Henry, *The Reminiscences of Henry Angelo*, London 1830

Ashbee, C.R. *Caricature*, London 1928

Atherton, H.M., *Political Prints in the Age of Hogarth*, Oxford 1974

Atherton, H.M., *'The British Defend Their Constitution in Political Cartoons and Literature'* Studies in Eighteenth Century Culture, Volume II, 1982

Baker, Rosemary, *Satirical Prints as a Source of English Social History*, Quarterly Journal of the Library of Congress, Summer 1982

Everitt, Graham, *English Caricaturists from Cruikshank to Leech*, London 1886

George, M. Dorothy, *Social Change and Graphic Satire, From Hogarth to Cruikshank*, London 1967

George, M. Dorothy, *English Political Caricature. A Study of Opinion and Propaganda*, Vol. I (to 1972) Vol. II (to 1832)

Gombrich, E.H., and Kris, E., *Caricature*, London 1940

Gombrich, E.H., 'The Experiment of Caricature' in *Art and Illusion*, London 1960

Gombrich, E.H., 'The Cartoonist's Armory' in *Meditations on a Hobby Horse*, London, 1963

Gould, A., Jensen, J., and Whitford, F., 'Politics in Cartoon and Caricature', in *20th Century Studies*, No. 13/14, University of Kent, 1975

Hillier, Bevis, *Cartoons and Caricatures*, London 1970

Hofmann, Werner, *Caricature: From Leonardo to Picasso*, London 1957

Houfe, Simon, *The Dictionary of British Book Illustrators and Caricaturists, 1800–1914*, Antique Collector's Club, 1978

Jones, M.W., *The Cartoon History of Britain*, London 1971, with a foreword by Michael Cummings

Jouve, M., *L'Âge D'Or De La Caricature Anglaise*, Presses De La Fondation Nationale Des Sciences Politiques, 1983

Klingender, F.D., *Hogarth and English Caricature*, London 1944

Kunzle, David, *The Early Comic Strip*, Los Angeles 1973

Lambourne, Lionel, *Caricature*, London 1983

Low, David, *British Caricaturists, Cartoonists, and Comic Artists*, London 1942

Low, David, *Ye Madde Designer*, London 1935

Lucie-Smith, Edward, *The Art of Caricature*, London 1981

Lynch, Bohun, *A History of Caricature*, London 1926

Marnham, Patrick, *The Private Eye Story*, London 1982

Mellini, Peter, and Matthews, Roy, *In Vanity Fair*, London 1981

Paston, George, *Social Caricature in the Eighteenth Century*, London 1905

Riely, John C., *English Prints in the Lewis Walpole Library*, Yale University Library Gazette, April 1975

Searle, Ronald; Roy, Claude; and Bornemann, Bernd, *La Caricature: Art et manifeste*, Geneva 1974

Spielmann, M.H., *The History of Punch*, London 1895

Stephens, F.G., and George, Dorothy M., *Catalogue of Political and Personal Satires . . . in the British Museum, to 1832*, 12 Volumes, reprinted 1978 (The whole collection has been photographed on microfilm, available in many libraries and museums)

Walker, Martin, *Daily Sketches, A Cartoon History of British Twentieth-Century Politics*, London 1978

Wright, Thomas, *A History of Caricature and Grotesque in Literature and Art*, London 1875

ANTHOLOGIES AND CATALOGUES

The Age of Horace Walpole in Caricature: An Exhibition of Satirical Prints and Drawings from the Collection of W.S. Lewis, Sterling Memorial Library, Yale University, 1973. Catalogue by John C. Riely, Introduction by Dale R. Roylance

Caricature and its Role in Graphic Satire, Exhibition Catalogue, Museum of Art, Rhode Island School of Design, 1971

Cartoon and Caricature from Hogarth to Hoffnung, Arts Council Exhibition, 1962. Introduction by Draper Hill, foreword by Osbert Lancaster

Getting them in Line, An Exhibition of Caricature in Cartoon, University of Kent at Canterbury, 1975. Essays by Colin Seymour-Ure and Stephen Bann

The Life and Times of Private Eye, ed. Richard Ingrams, 1971

Masters of Caricature: from Hogarth and Gillray to Scarfe and Levine. Introduction and commentary by William Feaver, edited by Ann Gould, London 1981

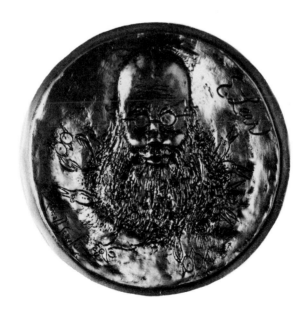

PL 72, CAT. NO. 197

LIST OF PLATES

(roman numerals indicate colour plates)